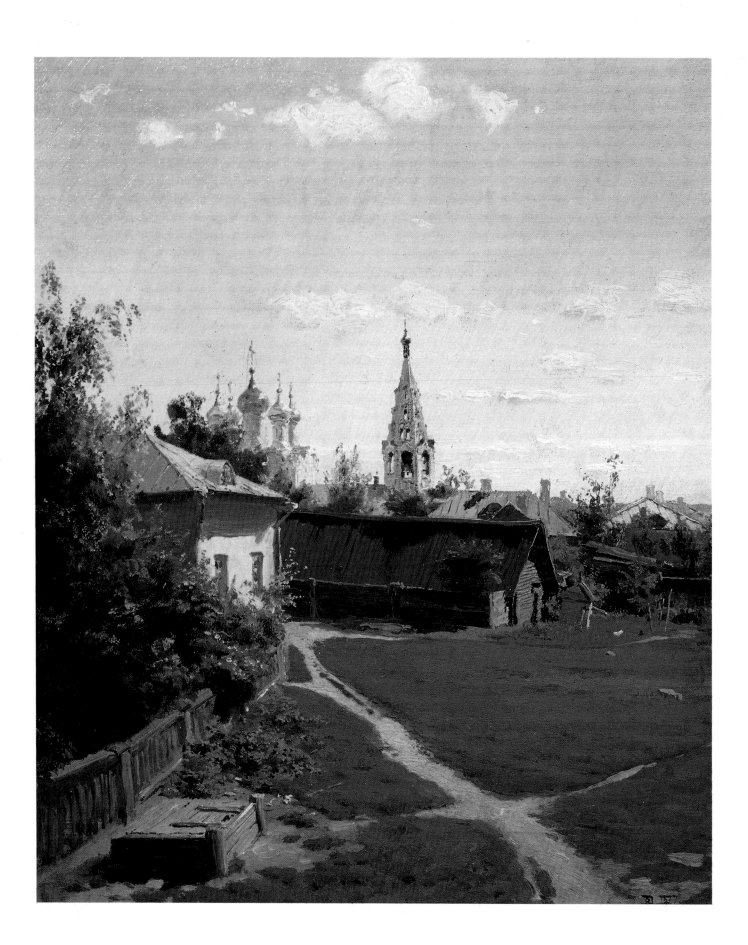

RUSSIA
The Land, The People
Russian Painting, 1850-1910

FROM THE COLLECTIONS OF THE

STATE TRETYAKOV GALLERY, MOSCOW

AND THE

STATE RUSSIAN MUSEUM, LENINGRAD

SMITHSONIAN INSTITUTION TRAVELING EXHIBITION SERVICE
WASHINGTON, D.C.

IN ASSOCIATION WITH

UNIVERSITY OF WASHINGTON PRESS
SEATTLE AND LONDON

Published on the occasion of an exhibition organized by the Smithsonian Institution Traveling Exhibition Service with the State Tretyakov Gallery, Moscow, and the State Russian Museum, Leningrad, and shown from October 1986 through June 1987 at:

RENWICK GALLERY, NATIONAL MUSEUM OF AMERICAN ART
Smithsonian Institution
Washington, D.C.

THE DAVID AND ALFRED SMART GALLERY OF THE UNIVERSITY OF CHICAGO
Chicago, Illinois

FOGG ART MUSEUM, HARVARD UNIVERSITY
Cambridge, Massachusetts

LIBRARY OF CONGRESS CATALOGING-IN-PUBLICATION DATA

Russia, the land, the people.

 Exhibition catalogue.
 Bibliography: p. 140
 Includes index.
 1. Painting, Russian — Russian S.F.S.R. — Exhibitions.
2. Peredvizhniki (Society) — Exhibitions. 3. Realism in art — Russian
S.F.S.R. — Exhibitions. 4. Painting, Modern — 19th century — Russian
S.F.S.R. — Exhibitions. 5. Painting, Modern — 20th century — Russian
S.F.S.R. — Exhibitions. 6. Avant-garde (Aesthetics) — Russian S.F.S.R. —
History — 20th century — Exhibitions. 7. Gosudarstvennyĭ russkiĭ
muzeĭ (Leningrad, R.S.F.S.R.) — Exhibitions. 8. Gosudarstvennaıa
Tret'ıakovskaıa galereıa — Exhibitions. I. Gosudarstvennyĭ russkiĭ
muzeĭ (Leningrad, R.S.F.S.R.) II. Gosudarstvennaıa Tret'ıakovskaıa
galereıa. III. Smithsonian Institution. Traveling Exhibition Service.
ND687.5.R4R86 1986 759.7'074 86-17840

ISBN 0-295-96439-1 (paper edition)
ISBN 0-295-96438-3 (cloth edition)

COVER: I. E. Repin, *Autumn Bouquet. Portrait of Vera Repina,* 1892 (p. 86).
FRONTISPIECE: V. D. Polenov, *A Courtyard in Moscow,* 1877 (p. 76).
FRONT ENDPAPERS: I. I. Shishkin, detail of *Goutweed, Pargolovo,* 1884(5?) (p. 106).
BACK ENDPAPERS: I. S. Ostroukhov, detail of *Golden Autumn,* ca. 1887 (p. 70).

Contents

Foreword

More than sixty canvases by distinguished artists from the second half of the nineteenth century and the beginning of the twentieth drawn from two major museums of the USSR — the State Tretyakov Gallery in Moscow and the State Russian Museum in Leningrad — are here presented to the United States of America. Every painting in this exhibition is a genuine masterpiece of Russian art; each is not only well known but also widely popular in the Soviet Union.

Embodied in these paintings are our land and people, our history, our spiritual life, our great and enduring cultural heritage. Here are our roots and our source. The Soviet people love and take pride in the great achievements of Russian culture of the nineteenth century. To us, this culture is very dear, for in it is found Russia's concern for the life of her country and her people, her true humanism, her high moral principles, and her transformation of national concerns to those of mankind worldwide. The giants of Russian literature and music — Leo Tolstoy, Fedor Dostoevsky, Anton Chekhov, Modest Mussorgsky, Peter Tchaikovsky, Sergei Rachmaninoff—asserted their faith in the people and in the celebration of truth and justice on earth, as did the Russian artists whose works are presented in this exhibition: Ilya Repin, Vasilii Surikov, Ivan Kramskoi, Ivan Shishkin, Aleksei Savrasov, Isaak Levitan, Valentin Serov, and many others. We hope that the American public will receive these works with attention and interest.

In 1987 a corresponding exhibition of American artists of the second half of the nineteenth century will travel to the Soviet Union. We believe that the exchange of these significant exhibitions with the Smithsonian Institution will undoubtedly promote better mutual understanding and greater spiritual closeness between our countries. For indeed, truly great artists throughout time have created works of art for the sake of peace and life on earth. To preserve them is our common goal.

GENRIKH P. POPOV

Chief of Administration
of Fine Arts and Preservation of Monuments,
Ministry of Culture, USSR

Preface

The Smithsonian Institution is proud to be able to bring to the American public a penetrating and naturalistic vision of Russia. It is the vision of nineteenth-century Russian artists — of themselves, their contemporaries, and their ancestors, and of the landscapes they created and fashioned into a shared web of perceptions. We in turn find much to share in those perceptions. In the experiences of both our nations we find an awakened sensitivity to landscape, not as a passive or stereotypical background but as a deeply loved, forcefully encountered root of common experience. In both, artists increasingly tended to find in the common people an arresting set of metaphors for emerging national consciousness and pride.

Assembled from the renowned collections of the State Tretyakov Gallery in Moscow and the State Russian Museum in Leningrad, *Russia: The Land, The People* offers an unparalleled opportunity for the American public to examine these works through the scholarship of Soviet curators and art historians. Their insight into their own artistic heritage contributes to a modern, international dialogue between colleagues that is among the most valuable aspects of this cultural exchange. Reaching beyond the ranks of specialists, we can only hope that the example of a productive dialogue has a favorable influence on the larger pattern of relations between our two countries.

As its part in the exchange, the Smithsonian will send to the Soviet Union an exhibition of American works of art from the same period. Beyond this formal and specific reciprocity, we will continue to seek new ways to share and communicate about the artistic and cultural resources of our two nations as steps toward mutual understanding.

ROBERT McC. ADAMS
Secretary, Smithsonian Institution

Acknowledgements

Art speaks a universal language that transcends cultural, geographical, and ideological boundaries. It depicts the way people see themselves and reveals an intimate view of a culture's personality. By sharing and exchanging these personal reflections, one culture allows another to see it more clearly. The Smithsonian Institution Traveling Exhibition Service (SITES) is honored to provide such an opportunity by presenting *Russia, The Land, The People: Russian Painting, 1850-1910* to a new audience in the United States.

These paintings capture an era fascinating in its complexity, and in many ways unfamiliar to Americans — a time when Tolstoy and Chekhov created an enduring legacy of Russian literature, and Tchaikovsky, Mussorgsky, and others gave the world a new and idiomatic Russian music. In all the arts, creative Russians turned to the scenes and sounds of their country's daily life. Rebelling against the classical rigidities of the European-style academies, they demanded reforms and sought an indigenous Russian voice. In painting, that voice found a place in the Circle of the Itinerants, whose work is represented in this exhibition. The Circle was an association of nineteenth-century Russian artists who not only captured daily life but organized and traveled their paintings to reach a wider audience. Following in their footsteps, SITES enjoys the privilege of bringing these important landscapes, portraits, and still lifes to audiences in three American cities.

It has been a great pleasure for us to work closely with our Soviet colleagues on this first reciprocal exhibition of Russian and American works of art since the signing of the Soviet-American cultural exchange agreement in the fall of 1985. This presentation of paintings by Russian masters of the nineteenth and early twentieth centuries is the initial part of the exchange, to be followed by *New Horizons: American Painting, 1840-1910,* an exhibition of American works that will begin its tour of the Soviet Union in 1987.

Such a unique exchange is the product of many individuals working toward a common goal. We are deeply grateful to the Ministry of Culture of the Soviet Union for its generous cooperation in the realization of this project. In particular, I would like to express our thanks to Vladimir F. Grenkov, Chief of the Department of Foreign Relations, Madame Alla Boutrova, Chief of Section, Foreign Relations, and Genrikh Popov, Chief of the Fine Arts Department, who also contributed a fine foreword to this catalogue. Our appreciation extends as well to Vladimir I. Litvinov in the Foreign Relations Department, Andrei V. Andreev, Chief of Section, Department of Fine Arts and Monuments Protection, and Victor Egorychev, Chief Art Curator.

The Soviet Ambassador to the United States, His Excellency Yuri V. Dubinin, has taken special interest in this cultural exchange. At the Soviet Embassy in Washington, the day-to-day assistance of Valery P. Sorokin, First Secretary, Cultural Section, Anatoli N. Bandura, Third Secretary, and Nikolai D. Smirnov, First Secretary of the Embassy, has been especially helpful.

Further thanks go to our colleagues in the Soviet Union who worked with SITES to select the paintings in this exhibition and catalogue: Vladimir A. Lenjashin, Director; Vladimir P. Bagenov, Vice-Director; Galina A. Polycarpova, Chief Curator; and Vladimir F. Kruglov, Chief Historian, all of the State Russian Museum in Leningrad. At the State Treytakov Gallery in Moscow I thank Yury K. Koroliev, General Director; Alexander G. Khalturin, Deputy Director; Lidia Romashkova, Chief Curator; Lidia I. Iovleva, Chief of Late Nineteenth-Century Art; and Katerina L. Selesneva, Foreign Exhibition Department. The professional dedication of their staffs is clearly evident in the essays and texts that comprise this publication. Boris N. Kutkov, President of Aurora Art Publishers in Leningrad, was instrumental in the development of the catalogue. I would also like to acknowledge the helpful advice provided by Academician Boris Piotrovsky, Director of the State Hermitage Museum, and Madame Irina Antonova, Director of the Pushkin Museum, in the early stages of the organization of the exhibition.

This cultural exchange was greatly facilitated by the staff of the United States Embassy in Moscow, and we are especially grateful to the Ambassador, Arthur Hartmann, and Raymond E. Benson, Counselor for Public Affairs, for their enthusiasm and support.

We have been privileged to draw on the expertise of many departments of the Smithsonian Institution in making the first part of this international exchange possible. SITES Exhibition Coordinator Donald R. McClelland took the lead role in organizing the exhibition with the assistance of many colleagues: Registrar Mary Jane Clark and her staff; Deborah Bennett, Director of Public Relations; Andrea Stevens, Publications Director; Nancy Eickel, Editor; Edie Rogat, Exhibition Assistant; and Sally Hoffmann, Symposium Coordinator. For technical assistance with the exhibition's production, thanks go to Mary Dillon, Karen Fort, and Walter Sorrell at the Office of Exhibits Central, and to Michael Monroe at the Renwick Gallery. We are also grateful to Christopher Addison for his work in designing the exhibition's installation. To the directors of our host museums and their cooperative staffs, we offer our warmest thanks: the Renwick Gallery of the National Museum of American Art, Smithsonian Institution; The David and Alfred Smart Gallery of the University of Chicago; and the Fogg Art Museum, Harvard University. For their support of international exchange, we are indebted to Smithsonian Secretary Robert McC. Adams and Assistant Secretary for Museums Tom L. Freudenheim.

This opportunity for the American public to discover an intriguing era of Russian painting would not have been possible without the generous support of the PepsiCo Foundation. I especially want to thank Donald M. Kendall, Chairman of the Executive Committee, PepsiCo, Inc., for sharing our conviction that all who view *Russia, The Land, The People: Russian Painting, 1850-1910* will be enriched by the experience.

PEGGY A. LOAR
Director, SITES

Introduction

Donald R. McClelland

The years between 1850 and 1910 can certainly be called among those of Russia's greatest cultural flowering. It was a time of tremendous progress in many fields of human endeavor, particularly the arts, which gave promise to the Soviet Union's achievements today. Yet for many Americans, the visual arts of this period are greatly overshadowed by our high esteem for Russian literature, music, and dance. As a result, this exhibition, *Russia, The Land, The People: Russian Painting, 1850-1910,* will present to many for the first time the pictorial accomplishments of this great cultural resurgence, a rebirth nurtured by a spirit of nationalism that spread across Russia, Europe, and America during the second half of the nineteenth century.

The richness and variety of artistic styles and subjects discovered in Russian painting of the late 1800s, so well represented in this exhibition, began with the realist traditions of the 1820s and ended in the early twentieth century. For decades prior to the years addressed here, however, the Petersburg Academy of Arts, founded in 1757, set the standard of aesthetic principles. The Academy long regarded neoclassical styles and mythological subjects as the only acceptable way to convey genuine beauty. Consequently, those artists who dared to depict the Russian landscape and folk traditions often found their work excluded from all exhibitions held at the Academy.

Among the first of the Russian painters who preferred to paint scenes of peasant life rather than seek acceptance in the Academy was Alexei Venetsianov (1780-1847). Although not included in this exhibition, Venetsianov's work is remarkable for its truth to nature, sense of poetry, and enduring feeling of calmness. In *Threshing Floor* (fig. 1), for example — painted 1822-23, first exhibited in the Hermitage in 1824, and now in the collection of the State Russian Museum — Venetsianov reveals his fascination with the light that filters through the log house and seems to escape out the open door. The artist confessed "that a twelve-year habit of painting in the grand manner impeded realization of his concept."[1] Soon after leaving the Academy around 1815, Venetsianov purchased a small estate, Safonkovo, in Tver Province (now Kalinin Province), where he formed his own art school and taught his pupils to recognize the beauty and pleasures of rural life. In this way, he inspired an entire generation of Russian artists, many of whom are represented in this exhibition, and encouraged them to express in their work a deeper appreciation of the Russian landscape and the unassuming demeanor of people who live close to nature.

1. *Artists on Art* (Moscow, 1969), v. 6, pp. 186-87, in Russian.

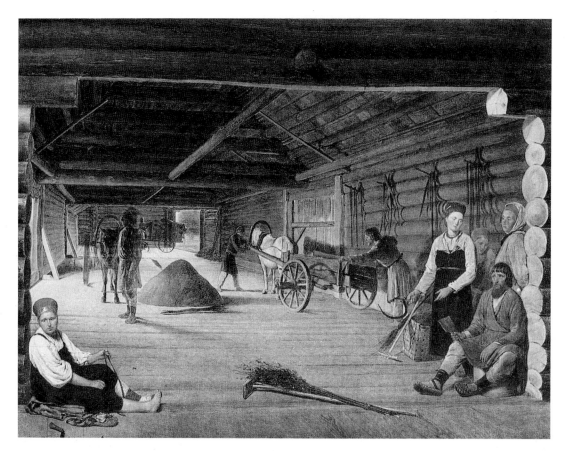

FIGURE 1. Alexei Venetsianov, *Threshing Floor*, 1822-23.
Oil on canvas, 66.5 x 80.5 cm, The State Russian Museum, Leningrad

Vladimir Stasov, a nineteenth-century critic of art, literature, and music, furthered the call for dramatic changes in how artists viewed and interpreted their subjects. As early as 1862 Stasov advocated a native Russian school of painting with "a national and original orientation in art," reinforcing his claim by adding, "The national costume of our ancestors certainly is no less colorful than that of the Romans." Others outside the Academy also pushed for a "move away from the classical and Paris-oriented school." The ensuing freedom, as Stasov phrased it, would allow artists "to paint a native land-scape, and one in which he lived with nature, so as not to have to invent each detail of his work, such as a foreign sky over a foreign land." American genre painters, artists of the Hudson River School, and American Impressionists certainly shared these sentiments. Artists in the United States and Russia alike began to explore their national heritage and turn away from European artistic formulas. Like their American counterparts, Russian artists soon considered their own native landscape as the ultimate embodiment of a national spirit.

One of the first artistic groups within Russia to concentrate on realistically depict-ing the landscape was the *Peredvizhniki,* or the Circle of the Itinerants, as they were popularly known. As a close-knit association of realist painters, the Circle of the Itiner-ants came to unite both the most talented and the most enlightened Russian artists in its aim "to provide the inhabitants of the provinces with the opportunity to keep up with the achievements of Russian art."[2] This directed effort led the early *Peredvizhniki* "to concentrate on Russian subjects, [which became] their way of participating in the gen-eral surge of national renovation, of demonstrating their recently acquired independ-ence and of asserting the new role for Russian art."[3]

2. Elizabeth Valkenier, *Russian Realist Art, the State and Society: The Peredvizhniki and Their Tradition* (Ann Arbor: Ardis, 1977), p. 226.
3. Ibid. p. 52.

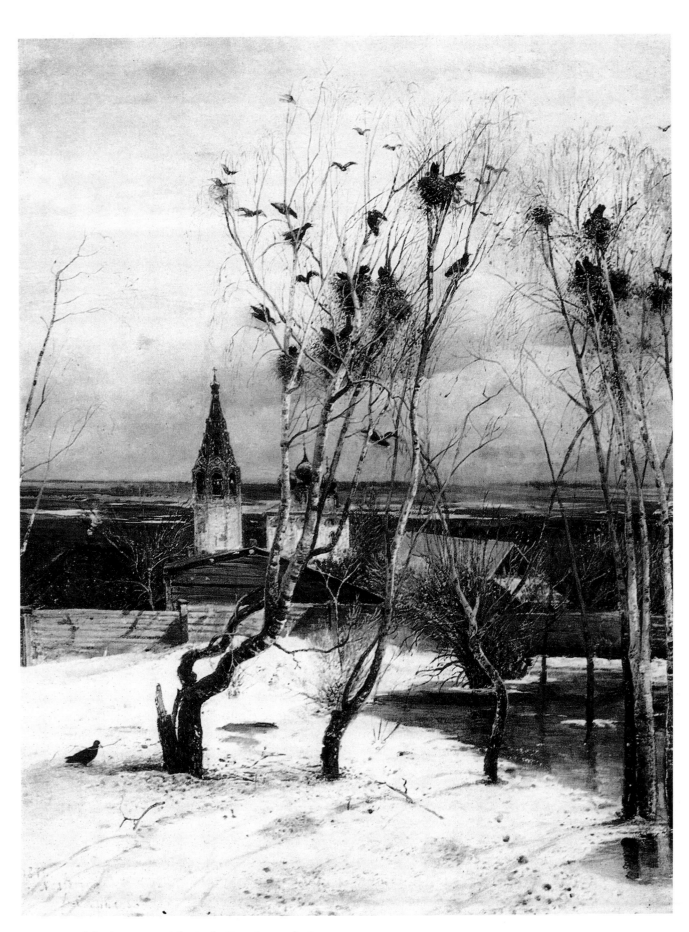

FIGURE 2. Aleksei Savrasov, *The Rooks Have Returned*, 1871
Oil on canvas, 62 x 48.5 cm, The State Tretyakov Gallery, Moscow

The Itinerants did indeed popularize realist art, especially through their paintings of idyllic landscapes, which received the highest praises from both liberal and conservative critics. Views of winding country roads, lush pine forests, and tiny, colorful villages spoke of Russia and its endless expanse, attributes long common in literature but fresh to the Russian pictorial vocabulary. In keeping with this renewed appreciation of the land, Itinerant Aleksei Savrasov emerged as a great supporter of the French practice of plein air painting. He gravitated toward lighting and tonal effects as well as forms that could double as spiritual metaphors in praise of nature and his native land. Based on the direct study of nature, as were most of his works, his painting *The Rooks Have Returned* (1871, fig. 2) shows how the gentle countryside could also be a source of contemplation.

Ivan Shishkin, who was known as the "Poet of the Forest," similarly derived his landscapes from nature, yet his images reveal how brilliantly he was able to harness his keen awareness of nature's beauty to his romantic imagination. Arkhip Kuindzhi produced some of the most dramatic of the Russian landscapes by melding the robust lighting of dawn or dusk to an often tranquil image, thus merging symbolism and naturalism without a hint of contradiction. Perhaps the greatest of the landscape painters was Isaak Levitan, whose paintings could almost serve as a setting for a play by Anton Chekhov, his friend. Critic Pavel P. Muratov praised Levitan's accomplishments in 1910: "[His] landscapes are closely connected with the whole sphere of Russian life. Their themes, colors, their very air expresses paeans of the familiar. They bring to our minds thousands of remembrances about places, people, events in our lives. Amidst these fields, forests, rivers, summer sunsets, the life history of each one of us was played out."[4] Although these artists responded to their particular subject in a different way, they were united in their desire to impart the landscape with meaning, whether it was pantheistic, educational, political, or as was frequently the case, all of these combined.

Similar to depictions of the Russian landscape, history painting elicited a warm and emotional response from many, though certainly not all of the Itinerants. More than simply presenting past events, such paintings often reflected contemporary political and social problems. Kramskoi admitted, "Historical painting is necessary . . . and must occupy present-day artists to the degree that it parallels the present . . . and gives the viewer food for thought."[5] Nikolai Ge, for instance, painted many scenes from history, such as *Peter the Great Interrogating Tsarevich Alexei at the Peterhof* (1871, fig. 3), in addition to numerous biblical subjects, which were displayed in the first of several annual exhibitions sponsored by the Circle of the Itinerants. This realistic treatment of a historical theme greatly affected the development of Russian painting.

Contemporary world events did not escape the attention of these artists either, especially Vasilii Vereshchagin, who studied with the French master Jean-Léon Gérôme after attending the Petersburg Academy of Arts. Living in Paris and Munich for extended periods, Vereshchagin became the most well-known Russian painter in Europe. The vast majority of his paintings, however, derived from his wide-ranging travels in Asia. His sense of Tolstoyian pacifism is evident in his paintings of the war in Turkestan and of the Russian-Turkish War, which he covered as an artist-reporter. War's horrors are depicted in an intensely realistic style somewhat reminiscent of photojournalism, as are the landscapes and scenes of local color that resulted from his trip through the Caucasia and India in 1874-76. (See Vereshchagin's *Moti Masdzhid ("The Pearl Mosque") in Agra*, 1874-76.)

Portraiture also shared in this artistic revitalization, as the *Peredvizhniki* expertly employed it to capture not only the sitter's inner character but also modern man's grow-

4. Ibid. p. 79. Originally in P. Muratov, "Peizazh v russkoi zhivopisi," *Apollon*, no. 4 (1910), p. 13.
5. Ibid. p. 82. Originally in letter of January 21, 1885, to A. Suvorin, *Ivan Nikolaevich Kramskoy. Pis'ma*, v. 2, p. 167.

FIGURE 3. Nikolai Ge, *Peter the Great Interrogating Tsarevich Alexei at the Peterhof,* 1871
Oil on canvas, 233 x 171 cm, The State Tretyakov Gallery, Moscow

ing confidence in his abilities and his time. Images of important cultural figures of the day, such as Vasilii Perov's sensitive portrait of the playwright A. N. Ostrovskii (1871), often became part of the extensive collection initiated by Pavel Tretyakov, founder of the art gallery in Moscow that still bears his name. Tretyakov's ardent belief in Russia's cultural importance easily meshed with the ideas of the Itinerants, which his extensive collection of portraits of famous nineteenth-century writers, scholars, and artists today attests.

Sharing Tretyakov's eagerness to support Russian artists was the industrialist and collector S. I. Mamontov, who established a retreat for the Itinerants and other artists at Abramtsevo, his estate outside Moscow. Among the numerous artists who visited the colony was Ilya Repin, the most celebrated painter of history scenes and portraits in the late nineteenth century. Repin met Mamontov as well as other European artists of the day in Paris, where he traveled after his graduation from the Academy. On his return to his native Russia, however, the depth and sensitivity of his realist works, particularly his portraits, attained their fullest expression.

In examining the variety of sitters who posed for Repin, the preponderance of sketches, drawings, and finished oils of Leo Tolstoy quickly becomes apparent. In *Lev Nikolaevich Tolstoi (Barefoot)* (1901), the simple figure of the author and his surroundings are painted with such freshness and assurance that all the sensuousness of nature's colors and warmth of the summer day are evoked. The art historian Grigory Sternin com-

ments, "The Tolstoy portrayed by Repin is altogether a simpler figure as an artistic image and as a human being. This simplicity is, however, associated in the artist's mind. . . . It was in this way that Repin on an artistic level connected the image of Tolstoy with that of Russia itself. And thus the artist, making use of his realist concepts, created his own poetic world and expressed his attitude to the historical fate of the country and of its people."[6]

Another member of the *Peredvizhniki,* like Repin, who participated in the Abramtsevo Art Circle was Valentin Serov. A student of Repin and a visitor to other European artistic centers, Serov became one of Russia's most brilliant and highly esteemed artists. More importantly, his works, with their serious and contemplative note, bridge the era of the Itinerants and the modernist movements of the early twentieth century.

The second half of the nineteenth century was a dynamic period in the history of Russian art, for the paintings produced by the Circle of the Itinerants played a significant role in the development of a Russian national consciousness. With the growing acceptance of the ideals of the *Peredvizhniki,* national awareness increased and classical values in art simultaneously slipped away from this vibrant school of painters. The emergence of these new directions caused the Itinerants to consider their supreme achievements nothing less than a rebirth of Russian art. As visitors to this exhibition examine and enjoy paintings by Perov, Kramskoi, Ge, Vereshchagin, and Repin, to name but a few, the hopeful ideals and universal appeal of this period of Russian art will become clear. Although these painters of the late 1800s were scarcely removed from the weight of centuries of Russian history, the Itinerants combined their artistic legacy with their passionate and unyielding faith in the importance of their day and in the certain brilliance of their future.

6. Grigory Sternin, *Ilya Repin* (Leningrad: Aurora Art Publishers, 1985), p. 22.

RUSSIA

The Land, The People

Russian Painting

L. I. Iovleva

The sixty-two masterpieces from the collections of the State Tretyakov Gallery in Moscow and the State Russian Museum in Leningrad present an opportunity to the American public to have the first extensive look at Russian art of the second half of the nineteenth century.

This was the time of the brilliant successes in Russian literature and music and of the flourishing creativity of such leading figures of Russian culture as the writers Leo Tolstoy, Fedor Dostoevsky, Ivan Turgenev, and Anton Chekhov, and the composers Modest Mussorgsky, Peter Tchaikovsky, and Sergei Rachmaninoff. Their names and their works have become known throughout the world and for over a century have been a part of world culture. The role and significance of Russian painting of this period is less universal in nature, although it too addresses the same concerns as Russian literature, was nurtured by the same sources, and similarly stemmed from the life of the Russian people. Consequently, it merits careful scrutiny and great interest.

Russian painting of the nineteenth century, like Russian literature of the same era, is singularly original and unprecedented. The essential, distinctive features of this period's painting are its deeply penetrating identification with the life of the people and its carefully postulated tenets on realism, a realism that exposed the sordid and unjust elements of society's hierarchy but also affirmed the plenitude and beauty of the world and the human condition.

This exhibition has two parts: the first presents the painting of the second half of the nineteenth century, the time of the flowering of Russian realism; the second part examines art at the turn of the century, when changes in the artistic temperament in Russia produced significant innovations in the nature of its art in the early twentieth century.

The highest achievements in Russian painting in the late 1800s are connected with the work of the artists affiliated with the Association of Traveling Art Exhibitions [hereinafter referred to as the Circle of the Itinerants], the largest organization of its kind and the only alliance of Russian artists in the nineteenth century. It would be no exaggeration to say that the history of Russian painting of that time was the history of the Itinerants; the history of the Itinerants was the history and future of Russian realism.

The Circle of the Itinerants and their exhibitions date from 1870. A group of young, realist painters from Moscow and Petersburg developed tenets for the new brotherhood and in 1871 organized its first traveling exhibition of works by member artists. These traveling exhibitions were consistently mounted in Moscow and Pe-

tersburg, as well as in a number of other cities in Russia, such as Kiev, Kharkov, Odessa, and Riga.

The formation of the Circle of the Itinerants has become a fact of great historical importance in Russian art. It marked not only the beginning of a new age in the development of art in Russia, a period of increased democratic activity and social responsiveness in art, but also the shedding of autocratic and bureaucratic controls imposed by the Imperial Academy of Arts, the omnipotent head of artistic life in Russia for over a century.[1]

An anti-academic tendency served as a stimulus in the formation of this new group, although not its only cause. The Itinerants considered their main objective, as it was written in the charter of the Circle, to be the "fostering of love of art in society." They held their exhibitions in many, sometimes very remote, parts of Russia, and by taking their paintings from city to city, the Itinerants greatly expanded their audience, which came to include the many thousands of people in the Russian provinces.

The huge and unprecedented success of the exhibitions organized by the Circle during the first twenty years of its existence attested to the timeliness of the idea of traveling exhibitions, their affinity to the ideals of enlightenment expounded by the Russian intelligentsia, and the struggles and desires of contemporary Russian society. "As of now, the works of Russian art, hitherto locked in Petersburg alone, within the walls of the Academy of Arts . . . will become accessible in general to every subject of the Russian empire," wrote Mikhail Efgrafovich Saltykov-Shchedrin about the first traveling exhibition. The writer and publicist also remarked, "Art ceases to be a secret, ceases to distinguish between those invited from the uninvited, by acknowledging everyone and his right to evaluate its accomplishments."

The Itinerants were the first in the history of Russian art to have sought and found their patrons outside the government, among the broadest audience of democratic circles of Russian society, and for the most part they sustained themselves on the support of these circles. They considered their economic and ideological independence a necessary condition for realizing their primary objective, that of creating art freely responsive to the "serious interests of the people." Proclaiming their freedom to work creatively, the Itinerants heeded the call of their leader Ivan Kramskoi to "learn obedience . . . from the needs of the people and harmony from one's inner sense of personal movement with the general movement." Realism became the Itinerants' standard.

In its fifty-year period of development, the realism practiced by the Itinerants passed through several stages. The first stage dates back to the end of the 1850s, to the time before the advent of the Itinerants, and continues until the early 1870s. These years witnessed an elevated social consciousness in Russia that was connected to the preparation and implementation of the reforms to repeal serfdom, a time of great hopes and substantial disillusionments. Progressive Russian art, the art of the young, impelled by the aim of "obeying the people's needs," saw these "needs" primarily in terms of eliminating the "darkness of medieval ignorance" through the merciless exposure of the dark and sordid aspects of Russian reality. This was the age of the flourishing of Russian critical realism. Leading the general movement to bring art and life closer together and championing the "invasion" of art into life were Russian literature and socio-political

1. The first serious demonstration by young Russian artists against the coercion and dictatorial policies of the Academy occurred as early as 1863. Fourteen exceptionally talented graduates of the Petersburg Academy of Arts who were admitted to a competition for a Gold Medal Prize publicly expressed their disapproval of painting a picture on a generally assigned subject. Unable to secure permission to choose their own subjects freely, the young rebels declined to take part in the competition and thus forfeited the privileges that could have been theirs. Upon leaving the ranks of the Academy, they organized, for the first time in Russia, an independent artistic brotherhood, the St. Petersburg Artel of Artists. Although short-lived, the group served as a model for the future Association of Traveling Art Exhibitions. This protest by young Academy members in 1863 is known in the history of Russian art as the "Rebellion of the Fourteen."

4

thought. The revolutionary-democratic criticisms of N.G. Chernyshevski and N.A. Dobrolyubov exercised an enormous influence upon art and society at that time.

In painting, the pathos of the 1860s embodied itself in the work of the leading artists of the "critical bent," the genre painters Illarion Prianishnikov, N. V. Nevrev, and Vasilii Pukirev, among others. Vasilii Perov was the most important of the group. In his paintings, Perov shows the reality of man's sufferings and losses with such deep understanding and sincere compassion that he is placed on a level equal to his famous contemporaries, the writers Dostoevsky, Aleksander Ostrovskii, and Nikolai Nekrasov, the great lamenters of all the "insulted and the injured." Kramskoi felt that the "abhorrence of evil" was key to Perov's emotional-poetic idiom. As a rule, the artist elevated an episode in the life of a "little man" to the standing of genuine human drama, as in *A Drowned Woman*. Perov's stylistic method very decisively revealed one of the most crucial aspects of Russian critical realism — artistic asceticism — and the deliberate "sacrifice" of the beauties of painting for the sake of the grim truth.

The most complete manifestation of this critical realism in art appeared in the unprecedented genre paintings of the 1860s, which became extremely popular in the creative work of young artists. The impact of the realist principles showed itself as well in portraits and paintings of historic events. In the latter, the realist trends were especially striking. History painting, having been more subordinate than other genres to the academic dictates of the 1860s, sought new methods of depiction and subsequently revealed a noticeable inclination toward more lifelike, plausible, and psychological interpretations of traditional historical subjects (Nikolai Ge, *The Last Supper*).

A new phase in the development of Russian realism began in the 1870s. After the reforms and in the face of emerging capitalism, realist, socially engaged Russian art was called upon to depict reality not only from the vantage of the merciless exposure of all that remained in the wake of "the accursed memory" of serfdom but also from the angle of the new social issues that the 1870s introduced. "The *muzhik* now is the judge, and his interests therefore require portrayal": with these words Ilya Repin expressed the creative aspirations of the Itinerants from the 1870s through the early 1880s. Images of peasants prevailed in their work of that time (Kramskoi, *Mina Moiseev*). These aspirations produced an impressive number of monumental paintings, genuine social epics on the lives of the people, such as Repin's *The Volga Boatmen* (1873, State Russian Museum) and *The Religious Procession in the Kursk Province [Gubernya]* (1883, State Tretyakov Gallery). [Neither work appears in this exhibition.] The Itinerants' range of genre themes was very broad. It included diverse, at times exceptionally witty, and often poetic subjects and motifs from the lives of peasants and from various layers of urban society as well. Vladimir Makovskii and Nikolai Iaroshenko touched on themes of the crumbling lifestyles of the nobility and the gentry, as did Vasilii Maksimov in *It's All in the Past*.

Vasilii Vereshchagin, a well-known Russian painter of battle scenes, was very close to the Itinerants in his understanding of the people's theme in art. He was perhaps the only significant master in the second half of the nineteenth century who did not formally join the Circle's traveling exhibitions. Like the Itinerants, Vereshchagin was deeply interested in the life of common people, particularly those in military uniforms. He saw his main task as exposing to the world, "through the use of paints," the truth about war, showing "war as the repulsive, grim, and colossal evil" that brings only death and ruin to the common man, as he depicted in *Mortally Wounded*. A tireless traveler, Vereshchagin employed ethnographic motifs in a substantial number of his works, such as *Dervishes Wearing Their Festive Clothes. Tashkent*.

As the Itinerants' understood their stated objective — "to serve the serious interests of the people" — they were free from narrow-mindedness. Far from limiting their art solely to the portrayal of scenes from the common man's life, they realized that their tableaus would not be complete without the depiction of the contemporary man whose

inner world was perturbed, a man "living in the age of newspapers and issues," as Kramskoi said. Portraits, always one of the most popular types of art in Russia, became the leading genre of the 1870s and 1880s. Almost every major artist of those years painted portraits: Perov, Iaroshenko, Repin, and Surikov, among others.

Ivan Kramskoi, the heart and soul of the Itinerants, was by profession a portrait painter. According to Kramskoi, a portrait must characterize its subject from the point of view of the sitter's moral convictions, that is, represent his civic standing, be it a public figure, such as *Portrait of the Poet N. A. Nekrasov,* or a private person *(Portrait of V.N. Tretyakova).*

Another famous portrait painter in Russia in the 1870s, Vasilii Perov, adhered to a similar concept in his understanding of the problems of portraiture. In distinction to Kramskoi, Perov strove for greater authenticity in depicting his subject's individual qualities. The artist precisely and accurately fixed the manner and substance of the way a man presented himself, that is, all his "external" trappings revealed his "inner" uniqueness as a man *(Portrait of the Playwright A.N. Ostrovskii).*

In their own creative work, a number of Russian painters followed Kramskoi's thesis as they portrayed, above all, "persons dear to the nation." As a result, there exists a large number of portraits of the most significant figures of Russian literature, art, and music of the nineteenth century, from the posthumous portrait of the composer Glinka by Repin to the portraits of Tolstoy, Dostoevsky, Turgenev, Nekrasov, Saltykov-Shchedrin, Chekhov, Mussorgsky, Tchaikovsky, Borodin, and Rimski-Korsakov, as well as many other outstanding representatives of the Russian people who made a tremendous contribution to the treasury of world culture. Pavel Tretyakov, founder of the Tretyakov Gallery, played an important role in the creation of this remarkable portrait gallery of figures from Russian culture. Tretyakov not only supported but also in many ways inspired the activities of the portrait painters.

Landscape paintings genuinely fascinated the Russian realist artists of the late nineteenth century. Through them, artists recognized the look of their native land and its importance to the people and their way of life. In this way, the Itinerants' landscapes directly related to their paintings of genre scenes. Even when the landscapes do not actually include people, human presence is nearly always felt in them. Here is nature inhabited by man, mastered and changed by his labors. Inasmuch as the subject of the Itinerants' works was "native and familiar nature," their landscapes frequently assumed a lyrical "expression" about the fate of one's country and its people.

The landscapes of the 1870s and 1880s clearly reveal two fundamental tendencies — a lyrical, poetic line, and a more objective strain. Aleksei Savrasov, Fedor Vasiliev, and his kindred spirit, Vasilii Polenov, are associated with the first, while the "forester" Ivan Shishkin is connected with second. Shishkin aspired to a greater objectivity in his presentations of landscape imagery. The work of Arkhip Kuindzhi, which is marked by romantic overtones, stands somewhat apart and alone.

At the apogee of Russian landscape painting of the second half of the nineteenth century stands the work of Isaak Levitan, who belongs to the younger generation of Itinerants. Levitan's paintings present the manifestations of nature in a variety and richness not seen before in Russian art. Nature harmonizes with the human soul. His landscapes portray nature just as they express the subtle conditions of man's psyche. His landscapes often include a hidden psychological message, and in that sense Levitan's art approaches the creative manner of his close friend, Chekhov.

The powerful development of democratic and realist tendencies in Russian painting between 1860 and 1870 prepared the way for the flourishing of the Itinerants' art and the activity of the most famous masters of the 1880s, Repin and Surikov. Their work gave the Itinerants' realism its long-awaited union of "truth" and "beauty."

Ilya Repin, the central figure of Russian art during the last quarter of the nine-

teenth century, was an artist exceptionally gifted in painting and was perhaps the most talented of the Itinerants, working in almost every genre. Besides the paintings on themes from his contemporary Russian society mentioned above, Repin also created a series of significant historical compositions (among them several variants of *The Cossacks*), as well as many portraits, landscapes, and still lifes. Perhaps his favorite genre was portraiture, for there his main creative gifts were revealed with particular brilliance: his insatiable love of and avid curiosity about life, his interest in and attention to man, and his almost Tolstoyan capacity to recognize the uniqueness of each person's inner world and to find repeatedly artistic devices capable of recreating that world, evidenced by *Portrait of the Pianist, Conductor, and Composer, A.G. Rubinstein; Autumn Bouquet. Portrait of Vera Repina;* and *Portrait of Semenov-Tian-Shanskii.* More than his fellow artists, Repin comprehended the aesthetic objectives of contemporary European art. Repin's influence on Russian art was enormous.

In contrast to Repin, an artist who was intimately connected to contemporary life, Vasilii Surikov was above all else an historian, the greatest of the Russian masters of history painting, and the best in expressing the concepts of the new realist historicism. His works presented history as a reality that could not be doubted or altered. Surikov had a gift for representing past events as if he had witnessed or participated in them. In this, Surikov's point of departure was not his archaeology but rather his powerful, creative imagination, his vivid and immediate vision of the past. Surikov was particularly interested in the sudden, critical moments in Russian history. His best paintings, such as *The Boyarina Morozova* and *The Morning of the Execution of the Streltsi* in the State Tretyakov Gallery, were devoted to events in the seventeenth century, the time of many rebellions and mass revolts. "He is attracted not by the Russian past in general but rather by the life of the people then, not by the peaceful everyday life but by its tragedy, 'liberties' taken by the masses, paid for in blood, and schism. . . . He is different from Repin, who is concerned about the fate of a single person. Surikov is concerned with more general devastation and the common retribution of many lives," wrote A. Efros, an art critic in the early twentieth century.

Indeed, Surikov viewed an historical event not through the eyes of a particular person, no matter the importance of that person, but through the eyes of the people, who were always the central, genuine heroes of the artist's works. In his compassion for the people, Surikov mirrored the composer Mussorgsky, who created grandiose, historical folk dramas. His paintings, temperamental and powerful, were alien to documentary archaeology or to illusory imitations of antiquity. Surikov's sense of poetic, expressive details from the costumes and lives of the people linked the Itinerants' realism with the creative searchings conducted by the next generation of artists.

Among the masters of Russian painting of the 1880s with Repin and Surikov should appear the name Viktor Vasnetsov, who set out "to arouse" the Russian artists' interest in the people's creativity and their folklore. Vasnetsov recreated in his own paintings images from Russian folk tales and poetic legends. Blessed with an extraordinary talent for decoration, Vasnetsov produced a whole series of outstanding monumental murals, such as those in St. Vladimir's Cathedral in Kiev and *Stone Age* in the State Historical Museum in Moscow. He also introduced radical changes in the art of painting theatrical backdrops. His national-romantic quests coincided with and in many cases defined the aspirations of the young artists in Moscow who united around Savva Mamontov, a Russian industrialist and patron of the arts. Through the Abramtsevo Art Circle, they sought the resurgence of folk art and the revival of the Russian folkcraft industry.

At the end of the 1880s and into the 1890s, the Association of Traveling Art Exhibitions included a large group of talented painters who were the younger generation of Itinerants: Abram Arkhipov, Vasilii Baksheev, Apollinarii Vasnetsov, Sergei Vin-

ogradov, Sergei Ivanov, Mikhail Nesterov, and others. Nearly all of them were disciples of the senior masters of the Itinerants and therefore directly continued their traditions. In the beginning, their creative interests, as before, were directed to the depiction of social motifs. They painted tableaus from the lives of peasants and laborers, although their favorite scenes were of life in large cities. At the same time, however, their art revealed distinctly new features as the problems of aesthetic composition, so to speak, increasingly crowded the social problems that sustained earlier Russian art. The ultimate model of realism, the genre painting, changed in character. In the 1890s scenes became smaller in scale and more intimate in content and form, as the landscape increasingly dominated the image. In general, landscapes became the leading form of art in Russia. Even paintings of historical subjects acquired properties of landscape scenes or of a landscape-genre nature (Ivanov, *The Family;* Nesterov, *Hermit*).

The majority of artists of the Moscow school were young Itinerants greatly influenced by Polenov and Levitan. As a rule, these Itinerants began practicing a type of plein air painting that approached Impressionism, and they ultimately developed their own style, which was marked by a combination of certain impressionistic devices with distinctive decoration. Many Itinerants preferred broad, free brushstrokes and bright paintings saturated with color. Toward the beginning of the 1900s, the majority of the plein air artists severed their ties with the Circle, although they remained true to the end of their days to the general realist and democratic traditions of the late nineteenth century.

During the 1890s, this same generation of realists included three outstanding Russian painters: Konstantin Korovin, Valentin Serov, and Mikhail Vrubel. Although these artists, especially Korovin and Serov, studied with the Itinerants, they had little connection with them. All of them were known as tireless seekers of new, untrodden paths in art. Korovin's progression in this endeavor was perhaps the most clear and simple. From the very beginning he felt essentially drawn to Impressionism in much of his art. Using this style as the foundation for his own artistic works, Korovin became known as the best Russian Impressionist for such paintings as *On the Seashore in the Crimea* and *Portrait of F.I. Chaliapin*. Korovin also merits acknowledgement in Russian art for having elevated the aesthetic value of the plein air sketch and of the freely drawn, rough sketch.

Valentin Serov, like Korovin, also began his career by focusing on the artistic devices of Impressionism. His famous paintings of the late 1880s — *A Girl with Peaches* and *A Young Woman in the Sun* (both are in the State Tretyakov Gallery but neither appear in this exhibition) — best embody the initial aspirations of this young artist who sought the meaning and poetry of human life in the harmony of nature. Afterwards, Serov was primarily successful as a portraitist. During the 1890s and 1900s, Serov justly enjoyed his recognition as the premier portrait painter of Russia. His portraits were always different and original, which is clearly evident in *Portrait of the Artist I.I. Levitan, Portrait of M.K. Oliv,* and *Portrait of S.P. Diaghilev.* A careful observer and a keen psychologist, as well as a subtle artist and a stylist, Serov managed to find a proper and, at times, surprising solution for each portrait.

The most original master of Russian art at the turn of the century, however, was Mikhail Vrubel. A symbolist, Vrubel expressed his ideas and images in terms of a style that in Russia was called "modern" and represented a variation of European *art nouveau* or Secessionism. The artist was haunted by motifs of the proud spirit of the evil-demon, the fabled maiden-swan, and the night siren, among others. Embodied in forms that were entirely concrete and material, his images, no matter how fantastic, were never severed from reality, since they were an expression of the artist's romantic dreams of the Beautiful and the Sublime. Unfortunately, paintings by Vrubel are physically so fragile and vulnerable that showing them in this exhibition is virtually impossible.

In the early twentieth century, new artistic ideas in Russian art readily emerged, which lead to a conflict of principles in classical Russian realism and simultaneously to a crisis in the art movement of the Itinerants. The former direct connection between art and reality now yielded a noticeable rift; the social ideals that once nurtured art exhausted themselves. An investigative and analytical approach to reality no longer responded to emerging challenges. In the rush of life's developments (The First Russian Revolution of 1905, World War I, 1914, and other impending changes), art needed not only to evaluate these contradictions but also to foresee and anticipate the future.

The structure of both Russian art and the artist's life became more complicated and lost its former purpose. During the two previous decades, the Circle of the Itinerants preserved their livelihood as they invariably attracted each emerging generation of artists. In the 1890s, various artistic groups took shape one after another and coexisted side by side, or replaced, or even directly negated each other. Among the more stable groupings were World of Art in Petersburg and the Union of Russian Artists in Moscow. Closer to the 1910 era, artistic life in Russia became ever more dynamic and dazzling. The age of triumphal individualism began in Russian art. In the second half of the nineteenth century, the individual style of each master was revealed, as it were, "within" the common style of each artist, thereby leaving styles principally intact. Now every artistic group paraded its ideological banner and united within the group different and, at times, contradictory personalities, practices, and styles.

This exhibition does not attempt to demonstrate the multiplicity and diversity of these changes or their sequence. Instead, it simply traces a few of them as it takes the viewer from the plein air paintings of the 1890s and the works of Arkhipov, Baksheev, and Filipp Maliavin. It proceeds from the Impressionism of the 1900s, seen in works by Korovin, Serov, Igor Grabar, and the young Kazimir Malevich, to the decorativism of the early efforts of Natalia Goncharova and Vasilii Kandinsky. Furthermore, by showing primarily the early works of the Russian avant-garde, this exhibition underscores these paintings' traditional origins and connections rather than their newness, which enables one to feel the special longevity of realist traditions. The main theme of the exhibition, however, is the realism and poetry in the Russian paintings of the 1850s to the 1900s, and their interrelationships and changes.

The State Tretyakov Gallery

G. S. Churak

The history of the State Tretyakov Gallery marks its beginning 130 years ago in May 1856 when a young Moscow merchant, Pavel Mikhailovich Tretyakov, acquired his first two paintings by Russian artists, thereby laying the foundation for his collecting on a large scale.

A merchant by birth, Tretyakov did in fact continue in his family's business like his grandfather and father, yet he did not merely collect works of art as if possessed by a passion to acquire and accumulate paintings for his own personal pleasure. As early as 1860, the young collector, then twenty-eight years of age, wrote his will in the form of a letter and established clearly that in the event of his unexpected death, he would provide "the capital . . . of 150 thousand rubles in silver . . . [as a] bequest to establish an art museum in Moscow. For me, a true and ardent lover of paintings, there can be no greater wish than laying a foundation for a public repository of fine arts that will bring advantage to many and pleasure to all." His will included an important codicil: "I would like to leave a national gallery that consists of pictures by Russian artists." Afterwards, Tretyakov's life was completely devoted to the realization of this lofty and noble aim.

Avidly interested in the development of the nation's art, Tretyakov carefully followed art exhibitions and noted everything that appeared in artists' ateliers. He rejoiced at every success of Russian painting and saw to it that all works indicating genuine talent and truthfully depicting Russian life would find their way into his art collection. A man of high culture and fine aesthetic taste, he selected the most significant and characteristic works of the Russian school of painting. The collector also enjoyed the tremendous respect of the artists, and they in return supported the creation of the first public museum of Russian art.

Above all, the collector Tretyakov paid close attention to the art of his contemporaries, the artists of a democractic bent with whom he identified deeply and on whose triumphs he built his hope for the flourishing of Russian art. He genuinely identified with the views of the Itinerants: Kramskoi, Perov, Surikov, Repin, Vasnetsov. Tretyakov's efforts ultimately resulted in the Gallery's collection having today the most complete representation of one of the most important periods in Russian art—the realist paintings of the second half of the nineteenth century.

Even though he started by collecting contemporary paintings, Tretyakov soon extended the boundaries of his collection. "I have set an objective to acquire examples of the Russian school as it evolved over time," Tretyakov wrote to one of his correspondents. Art of the early nineteenth century—works by Karl Briulov, studies by Alexander Ivanov, paintings by Alexei Venetsianov—in addition to works of art of the eighteenth century and later, Ancient Russian art, all gradually found their way into Tretyakov's collection, which very quickly outgrew the confines of a private collection. As early as the beginning of the 1880s, his gallery rose in status to become a true museum, open to all without deference to birthright or title.

Progressive individuals in Russia greatly admired the collector's efforts. "He took his pursuit to grandiose, unprecedented dimensions, and alone carried on his two shoulders the question of the existence of an entire school of Russian painting. A colossal, unexampled feat," wrote one of his contemporaries.

In 1892 Tretyakov turned over to the city of Moscow his entire collection as well as that of his deceased brother. There were about 2,000 works in his collection by that time. Until the end of his life in 1898, Tretyakov remained a gallery patron, tirelessly concerned with acquisitions.

After Tretyakov's death, a council elected by the Moscow city *Duma* headed the Gallery. It included distinguished collectors from Moscow, artists, and representatives of the Tretyakov family. The council continued to collect actively as it tried to leave no significant works of art outside the Gallery. In accordance with the council's decision in the early 1900s, Tretyakov's residence was merged with the exhibition halls, and the entire complex was given a common facade executed from a design by the artist Viktor Vasnetsov. The facade resembled a *terem,* an ancient Russian room, and fit in easily with the antique look of the capital city.

A new page in the history of the Tretyakov Gallery began after the October Socialist Revolution. On June 3, 1918, Lenin signed the decree that nationalized the Gallery, transferring the municipal property to the state and making the Gallery national. This resulted in a rapid growth of the Gallery's collections. From other nationalized private collections and reformed minor museums in Moscow, a huge number of works from the eighteenth and early nineteenth centuries joined the original collection and thus filled out the inevitable and natural gaps in Tretyakov's collecting activity. Even though Tretyakov might have considered his collection of paintings from the second half of the nineteenth century exhaustive, this section of his collection became even richer. The number of works by twentieth-century masters also grew substantially.

During the post-Revolution period, new departments appeared in the Gallery for the first time. Today the pride of the State Tretyakov Gallery is its collection of Ancient Russian art. At the end of the nineteenth century, this area of the nation's cultural history had just begun to attract the attention of scholars and collectors. Tretyakov's collection claimed sixty-two significant icons. This unique collection of Ancient Russian art now numbers more than 4,500 works from the eleventh to the seventeenth centuries, including *The Virgin Mary of Vladimir,* the rarest work of art of the twelfth century, and the famous *Trinity,* created by the artistic genius of the great master of the early fifteenth century, Andrei Rublev. The Russian drawing and sculpture collections have been almost assembled anew after the Revolution. The most actively growing portion of the State Tretyakov's Gallery's collection, however, is in the areas of painting, graphic arts, and sculpture by Soviet artists from all national schools within the Soviet Union. It now comprises over half of the Gallery's entire holdings, surpassing 60,000 pieces and growing steadily through annual acquisitions of works of Ancient Russian as well as contemporary Soviet art.

The State Tretyakov Gallery has long been not only the largest repository of Russian and Soviet art but also an extremely important scholarly center for their study and promotion. Exhibitions mounted in the halls of the Gallery, in other museums in the Soviet Union, and in many countries in Europe, Asia, and America have made the State Tretyakov Gallery one of the best known museums in the world.

The State Tretyakov Gallery has now entered a new stage in its life, with reconstruction and renovation of its old buildings and construction of new exhibition wings. Viewers will soon be able to see the Gallery's rich collections, in all their plenitude and variety, placed in the carefully conserved but expanded and modernized historical building of the P. M. Tretyakov Gallery.

The State Russian Museum

M. N. Shumova

The State Russian Museum, the largest museum of Russian art in the USSR (along with the State Tretyakov Gallery), is located in the center of Leningrad, in the architectural complex of Arts Square. The museum occupies two buildings: the former Mikhailovski Palace, an outstanding monument of Petersburg architecture (1819-1825, architect K. I. Rossi); and the west wing (1914-1916, architect L. N. Benois).

Despite the intense cultural life in Petersburg, then the capital of Russia, there was no state museum devoted to national art until the end of the nineteenth century. Some works by Russian masters were held in the Hermitage (which for a long time had the character of a palace collection of the imperial family); a few were in the Academy of Arts, where there were mainly works by its students, but most were in numerous private collections. For this reason, the establishment of the Russian Museum was an important event in the artistic life of the city.

The Russian Museum (first named the Russian Museum of the Emperor Alexander III) was established in 1895. In order to have a place for the museum, the Treasury acquired the Mikhailovski Palace, and its interior was partially redone (architect V. F. Svinin). The core of the museum collection was paintings by native masters from the Hermitage collection (which then comprised only eighty works), paintings from the Academy of Arts, the Alexander Palace in the Tsarskoe Selo, and from other palace holdings. A large portrait collection assembled by A. B. Lobanov-Rostovskii was also acquired.

The Museum opened to the public in March 1898. New departments appeared in the following years: ethnography in 1902 and history in 1913, although their exhibits were handed over to other museums in 1934. During the first ten years of its existence, the Museum doubled its art holdings and gained wide popularity. By 1912 museum attendance reached almost 220,000 visitors, which surpassed annual attendance to the Hermitage. From 1914 to 1917, during the course of World War I and the Great October Socialist Revolution, the Museum was closed and some of the exhibits evacuated.

A decree from the Council of the People's Commissars on October 5, 1918, determined the proper way to protect and register these works of art and antiquity. Nationalized private art collections and holdings of abolished organizations that passed through the specially established state commissions and the State Museum Fund found their way into museums. During the first decade of Soviet rule, the art fund of the Russian Museum increased several times; work in the Museum was supervised by the Museum Council, which included important representatives of the art community of Petrograd.

In the 1920s the Museum embarked on collecting the newest and the most contemporary in painting. The growth of holdings led to the differentiation of objects by period and type and to the creation of new museum subdivisions. Thus, in 1923 the department of decorative and applied arts came into being, in 1926 the department of current trends (which later became the department of Soviet art), and in 1937 the department of folk art. In the 1930s, the Museum rose to the level of the leading museum in the country. Within its walls the staff pursued many different activities in the areas of exhibitions, teaching, and scholarship.

During the years of the Great Patriotic War (1941-1945) and the 900-Day Siege of Leningrad, the Russian Museum endured difficult trials. Its surroundings were hit by fire and incendiary bombs; the building was left without water, heat, or windows; the Benois wing was badly damaged; and the staff perished of hunger and shelling. Those who lived, however, carried on their museum work and heroically saved many of the art treasures by evacuating them deep into the interior of the country. In July 1944 an exhibition of works by artists from the Leningrad Front was held in several halls of the Museum. (Fifteen thousand people attended the exhibition.) Another special exhibition commemorated the 100th birthday of Ilya Repin. On May 9, 1946, the halls of the Mikhailovski Palace displayed the first postwar exhibition of Russian art. In 1949, following the restoration of the damaged wing, the whole museum resumed its work.

In the 1950s, construction in the Museum included rebuilding the gallery that linked the two wings and building a new lecture complex. As a result of a general reinstallation carried out during the 1950s, works from every division of the Museum's holdings were shown for the first time. Today the State Russian Museum contains works of Russian and Soviet painting, sculpture (among the richest collections in the USSR), graphics (the most comprehensive in the country), decorative and applied arts, and folk art. The total number of objects is about 340,000.

The State Russian Museum is one of the key scholarly/artistic entities in the Soviet Union engaged both in extensively teaching about, exhibiting, and researching works, and in museum consultation. Annual attendance to the Museum approaches 1.5 million people, the number of tours through the exhibition halls nears eleven thousand, and the number of lectures presented by the museum staff is about 2,000 per year. Scholarly works by the museum's staff are published in various special editions, such as "Reports" on collections of works by theme and exhibition catalogues.

The State Russian Museum has taken part in many foreign exhibitions. In the last five years, Russian art from the nineteenth and twentieth centuries was shown, in particular, in the exhibitions *Russian Art of the First Half of the Nineteenth Century* and *Shostakovich and His Time* (Federal Republic of Germany), *"The World of Art"* (Italy), *Art and Revolution* (Japan), and *Century of Enlightenment* (France), among others.

Catalogue of the Exhibition

All works in the exhibition are lent by the State Tretyakov Gallery, Moscow, and the State Russian Museum, Leningrad. Dimensions are in centimeters, height precedes width. Catalogue entries were prepared by the following people:

For paintings from the STATE TRETYAKOV GALLERY, Moscow:

L. I. IOVLEVA

For paintings from the STATE RUSSIAN MUSEUM, Leningrad:

E. V. BASNER
G. K. KRECHINA
M. N. SHUMOVA
I. N. SHUVALOVA

Many of the artists featured in *Russia: The Land, The People* belonged to the Association of Traveling Art Exhibitions and were often identified as the *Peredvizhniki,* the Wanderers, or the Itinerants. In the context of this exhibition and catalogue their organization is called the Circle of the Itinerants.

The transliteration of Russian personal and place names follows the standard Library of Congress system, retaining the use of "ii" instead of "y" and "skoi" instead of "skoy." Exceptions to this include names that are in common Western usage, such as Kandinsky and Leo Tolstoy. (A few names may appear differently in other English-language publications. For instance, Nikolai Nikolaevich Ge may be found as Gay elsewhere.) Names are also spelled to facilitate pronunciation, although the soft sign in the first and last names has been omitted.

Several entries include quotations about the artists made by the Russian painter Aleksander Nikolaevich Benois (1870-1960) in his 1902 book, *Istoriia russkoi zhivopisi v XIX veke (The History of Nineteenth-Century Russian Painting).*

Abram Efimovich Arkhipov

Egorovo, Riazan Province (now Riazan Oblast) 1862-1930 Moscow

A Northern Village

Abram Efimovich Arkhipov studied at the Moscow School of Painting, Sculpture, and Architecture from 1877 to 1888 with the Itinerant artists V. G. Perov, V. D. Polenov, and V. E. Makovskii, as well as at the Petersburg Academy of Arts in 1884-1886 with P. P. Chistiakov. Although he lived in Moscow, Arkhipov made numerous trips, beginning in 1902, to the northern regions of Russia and to the White Sea coast. In 1891 he became a member of the Circle of the Itinerants, in 1903 an active member of the Union of Russian Artists, and in 1924 a member of the Association of Artists of Revolutionary Russia (AKhRR). In addition, Arkhipov taught at the Moscow School of Painting, Sculpture, and Architecture from 1894 to 1920 and at the Higher Art and Technical Studios (Vkhutemas) in 1922-1924. In 1927 he was awarded the rank of People's Artist of the Russian Soviet Federal Republic in recognition of his being a painter of landscapes, genre scenes, and portraits. During the post-Revolution years, Arkhipov was acknowledged as one of the prominent representatives of the older generation of Soviet artists and as a follower of the realist traditions in Russian art at the end of the nineteenth century.

Oil on canvas, 83 x 68 cm, 1903

Signed, lower left: A. Arkhipov

The State Tretyakov Gallery, Moscow

Inv. #5597

Acquired in 1917; earlier in the collection of V. O. Girshman, Moscow

Painted like a subdued form of poetry about nature in northern Russia, the white summer nights, soft, overcast days, and tiny, colorful villages by lakes and rivers greatly attracted the artist's attention for many years.

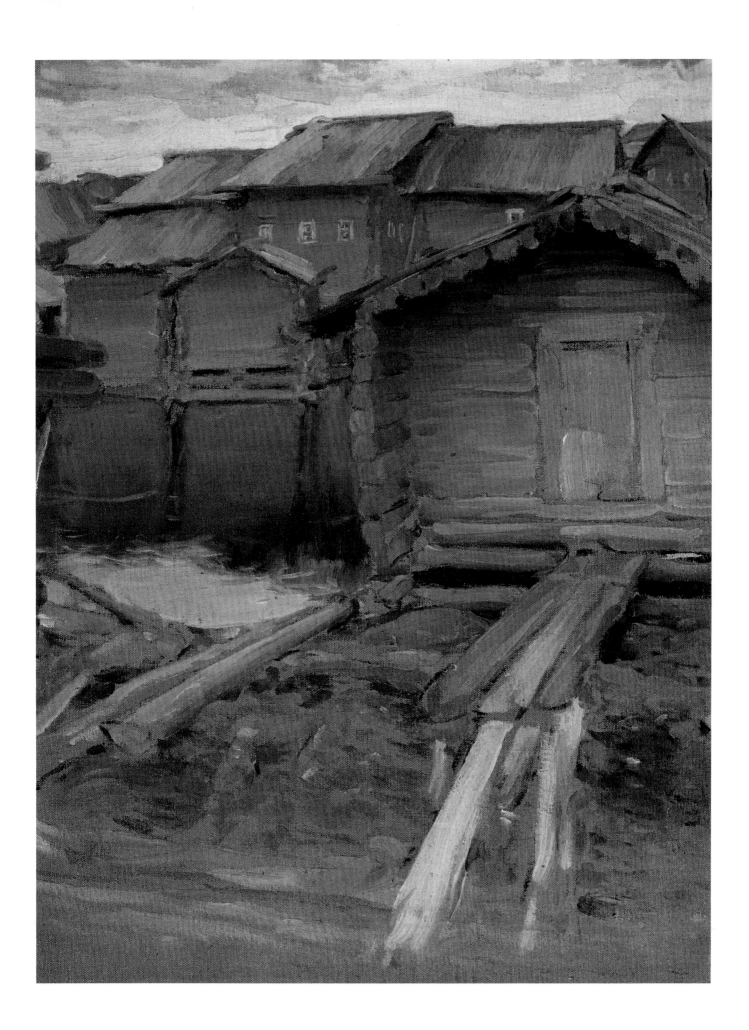

Vasilii Nikolaevich Baksheev

Moscow 1862-1958 Moscow

A Girl Feeding Doves

Vasilii Nikolaevich Baksheev attended the Moscow School of Painting, Sculpture, and Architecture from 1877 to 1888, studying with E. S. Sorokin and A. K. Savrasov as well as with V. D. Polenov and V. E. Makovskii. A resident of Moscow, he joined the Circle of the Itinerants in 1896 and in 1922 became a member of the Association of Artists of Revolutionary Russia (AKhRR). He taught at the Moscow School from 1894 to 1918 and in a number of other art schools in Moscow during the 1930s and 1940s. Baksheev was esteemed as a People's Artist of the USSR for his paintings of genre scenes, portraits, and still lifes. After the Revolution, Baksheev was considered a leading representative of the older generation of Soviet artists and was recognized as a follower of realist Russian art of the late nineteenth century.

Oil on canvas, 54 x 24.5 cm, 1887

Signed, lower left: '87 V. Baksheev

The State Tretyakov Gallery, Moscow

Inv. #1436

Acquired by P. M. Tretyakov in 1887 from the artist

One of the earliest works by Baksheev, P. M. Tretyakov acquired the painting at an exhibition of student works. This is a striking example of the Russian realist artists' general interest in plein air painting in the 1880s and early 1890s.

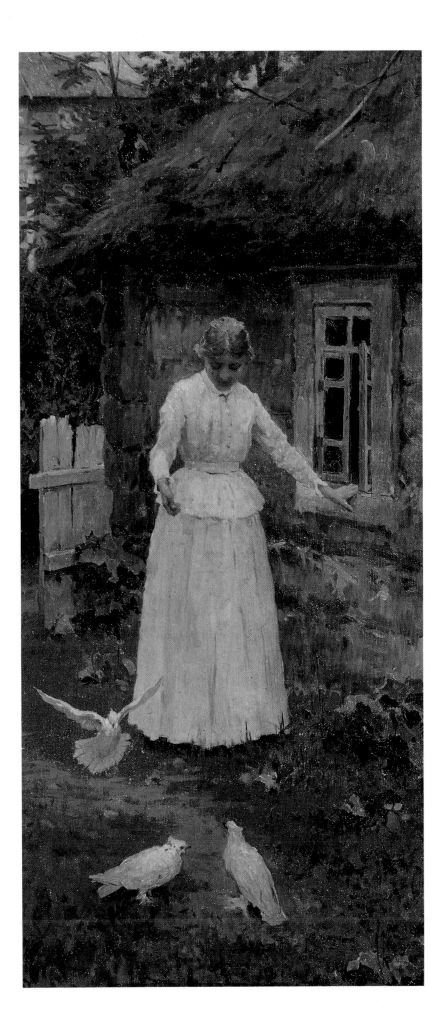

Nikolai Nikolaevich Ge

Voronezh 1831-1894 Iivanovsk Khutor (now Chernigov Oblast)

The Last Supper

Nikolai Nikolaevich Ge, an artist of great and original talent, studied at the Petersburg Academy of Arts from 1850 to 1857, where he was strongly influenced by the work of K. P. Briulov. (He became a member of the Academy in 1863.) On a scholarship from the Academy, Ge lived in Italy for twelve years (1857-1869). There he became closely associated with the well-known writer and revolutionary, A. I. Herzen, who had a profound effect on the artist's social views. In Rome he met the artist A. A. Ivanov and was fascinated by his work. Upon his return to Petersburg in 1869, Ge became an enthusiastic supporter of the idea to organize the Circle of the Itinerants. Subsequently he became a founding member and a constant participant in their exhibitions, where his works represented a new style of Russian history painting and portraiture.

Ge's friendship with L. N. Tolstoy caused him to follow the religious, philosophical teachings of this great writer. From 1876, Ge lived on a homestead in the Ukraine, farming and practicing Tolstoy's call for simple living. During this time, Ge attempted to paint scenes from the gospels and tried, like Tolstoy, to create his own "gospels" with paints. When shown in exhibitions, these paintings both provoked heated debates and arguments, and won Ge a measure of authority and recognition.

Oil on canvas, 66.5 x 89.6 cm, 1866

Signed, lower right: N. Ge Florence 1866

The State Tretyakov Gallery, Moscow

Inv. #5228

Accessioned from the Rumiantsev Museum in 1925; earlier in the collection of K. T. Soldatenkov, Moscow

The artist's copy of this painting, of the same name but smaller in scale, is in the State Russian Museum in Leningrad. When working on the image of Christ, Ge used characteristic features of A. I. Herzen's distinctive appearance.

"People of the sixties remember Ge's great fame and the profound impression generated by his *Last Supper of Christ with His Disciples*. . . . The 'troubled spirit' of Christ is interpreted daringly and originally, almost to the point of genius. It is impossible to forget the living figure of the youth, John . . ." (from the reminiscenses of I. E. Repin).

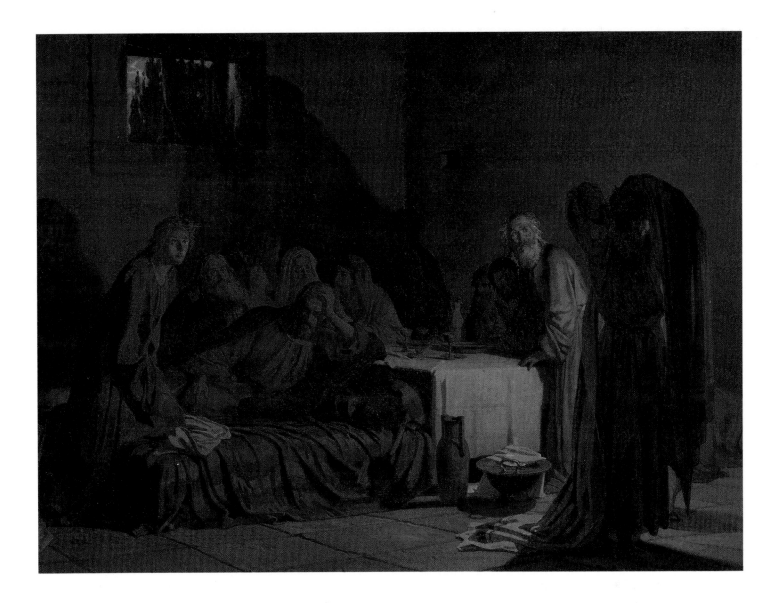

Nikolai Nikolaevich Ge

Christ and His Disciples on Their Way to the Garden of Gethsemane

Oil on canvas, 65.3 x 85 cm, 1888

The State Tretyakov Gallery, Moscow

Inv. #2638

A sketch of the painting, dated 1889, is located in the State Russian Museum in Leningrad.

". . . If I were required to point out new art examples of the highest religious content, I would point to in the verbal arts certain dramas of Corneille, Schiller, to the works of V. Hugo, his *Les pauvres gens, Les Miserables;* all the novels by Dickens; Dostoevsky's *House of the Dead; Uncle Tom's Cabin;* and to some stories of Maupassant . . .; in painting I would point to Hogarth, Millet, L'Hermitte, Ge . . ." (L.N. Tolstoy's notes to the article "What is Art").

Natalia Sergeevna Goncharova

Nagaevo, Tula Province 1881-1962 Paris

Grain Harvest

Like many of her fellow artists, Natalia Sergeevna Goncharova attended the Moscow School of Painting, Sculpture, and Architecture (1901-1909), where she studied in the department of sculpture with S. M. Volnukhin and P. P. Trubetskoi. She independently learned to paint with the advice of K. A. Korovin and under the tutelage of M. F. Larionov in Moscow before she moved to Paris in 1915. Goncharova was one of the organizers of the first *Jack of Diamonds* exhibition (1910) and of the later exhibitions *Donkey Tail* (1912), *Target* (1913), and *No. 4. Futurists, Rayonists, Primitive* (1914). She also participated in the exhibitions *The Wreath-Stefanos* (1907-1908), *The Golden Fleece* (1908-1910), and those sponsored by the Union of Youth (1910-1913) and World of Art (1911-1913). Her work underwent a complex development, from Impressionism and Post-Impressionism through variations of Cubism and Fauvism (primitivism) to Futurism and the beginnings of non-objective art. A follower of M. F. Larionov's "rayonism" theory, the artist created landscapes, portraits, and genre scenes. Goncharova was also famed as an artist of theater scenes, who worked from 1914 to 1929 with S. P. Diaghilev.

Oil on canvas, 96 x 103 cm, 1908

The State Russian Museum, Leningrad

Inv. #1603

Acquired from the Department of Fine Arts of the People's Committee of Soviet Commissars in 1920

Typical of the so-called "primitivist period" in Goncharova's career, this work's distinctive features include an emphasis on painting style, expressive gesture, and intense color saturation, all characteristics that the artist developed through her study of folk art. In the summers, Goncharova spent long periods of time at the family's Cotton Factory estate that once belonged to N. N. Goncharova, A. S. Pushkin's wife. Themes of peasant life and labor became the leading subjects of her work. Unlike most of the young Russian painters of the early 1900s who strongly preferred "nonfigurative" works, primarily still lifes, Goncharova urged, "In painting don't fear literalness, illustration or all the other current taboos."

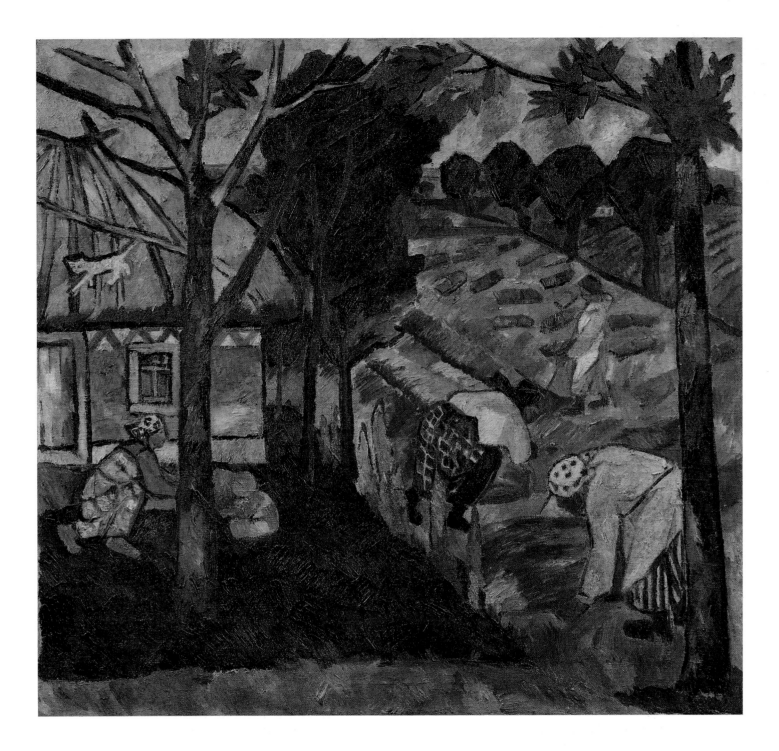

Igor Emmanuilovich Grabar

Budapest 1871-1960 Moscow

A Ray of Sun

After he graduated from the department of law at Petersburg University in 1893, Igor Emmanuilovich Grabar turned to art, studying at the Petersburg Academy of Arts (1894-1896), at I. E. Repin's studio, and at Anton Azbé's school (1896-1898) in Munich, where he eventually taught. A highly esteemed artist, Grabar became a member of several distinguished societies, including World of Art (1902), the Union of Russian Artists (1903-1910), a life member of the *Salon d'Automne* in Paris (1906), the Academy of Arts (1913), and in 1947, an active member of the Academy of Arts of the USSR.

In addition to participating in the exhibitions of the Moscow Society of Art Lovers (1898-1899), the Society of Moscow Painters in 1925, and the Society of Moscow Artists three years later, Grabar taught at Moscow University from 1920 to 1946 and at the Moscow Art Institute from 1937 to 1943, where he also served as its director. He headed as well the All Russian Academy of Arts (1942-1947). For seven years he acted as director of the Tretyakov Gallery (1918-1925) and later, from 1944 until his death in 1960, as director of the Institute of Art History of the Academy of Science of the USSR.

Grabar was recognized as a People's Artist of the Soviet Union in 1956 for his work in the areas of landscape, still life, and portrait painting and for his images of historical revolutionary themes. An art historian, Grabar was also a prominent specialist in the restoration and preservation of works of art and antiquity. His style was based on his creative mastery of the principles of Impressionism.

Oil on canvas, 79 x 42.5 cm, 1901

Signed, lower right: I. Grabar 1901

The State Tretyakov Gallery, Moscow

Inv. #3728

Acquired from the artist in 1902

Grabar's landscapes and still lifes of the 1900s are striking examples of Russian painters' masterly use of the devices of late Impressionism to depict their national motifs.

Igor Emmanuilovich Grabar

The Blue Tablecloth

Oil on canvas, 81 x 80 cm, 1907

Signed, lower right: Igor Grabar January 1907

The State Russian Museum, Leningrad

Inv. #2452

Accessioned from the Leningrad Purchase
Commission in 1949

The still life *The Blue Tablecloth,* characteristic of
the artist's early period, was completed at the
Dugino estate near Moscow, where Grabar set-
tled upon his return from Paris. In his "auto-
monograph," Grabar recalled that at that time
his aim was "to express on canvas the sense of
color of a given phenomenon, its colorful
nature." More than a mere depiction of objects
on a table, the artist was fascinated by the
beauty of the juxtaposition of their various
forms and colors.

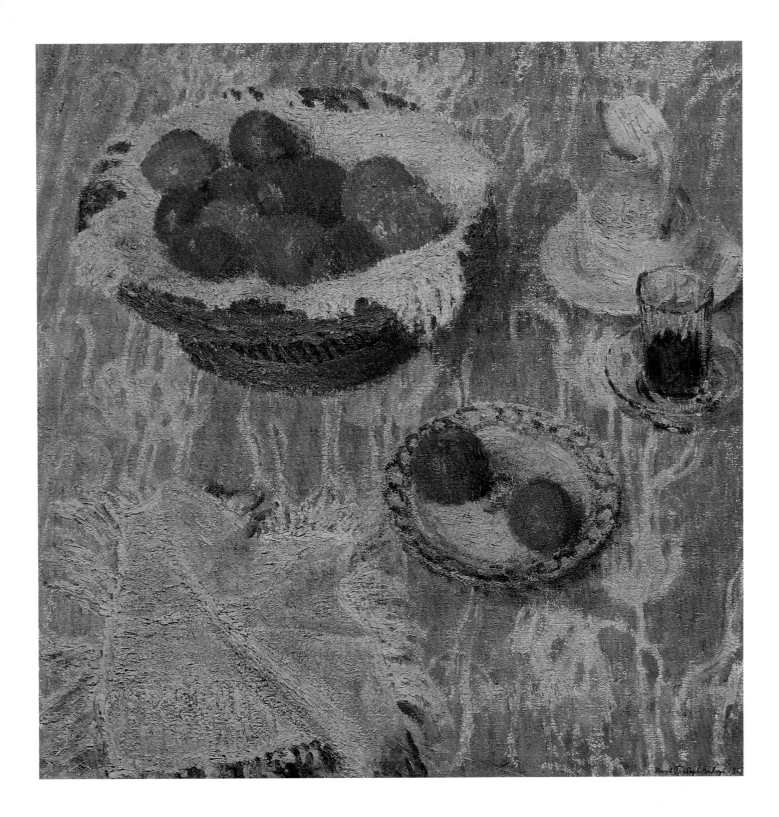

Nikolai Aleksandrovich Iaroshenko

Poltava 1846-1898 Kislovodsk

Student

Nikolai Aleksandrovich Iaroshenko was taught by I. N. Kramskoi when he attended the Drawing School of the Society for Encouraging Artists from 1863 to 1867. For the next seven years, until 1874, Iaroshenko took classes at the Petersburg Academy of Arts. Upon completion of his military service in 1892, he lived primarily in Petersburg and, during his last years, in Kislovodsk. He traveled widely in Europe, the Near and Middle East, and Russia. A portraitist and a painter of genre scenes, Iaroshenko also made drawings and emerged as a leading proponent of Russian realism in the 1880s and 1890s. He took an active role in the Circle of the Itinerants, not only exhibiting with them regularly beginning in 1876 but also serving on their administrative board.

Oil on canvas, 87 x 60 cm, 1881

Signed, lower left: N. Iaroshenko 1881

The State Tretyakov Gallery, Moscow

Inv. #689

Acquired by P.M. Tretyakov

The painting recreates the typical appearance of a Russian student-democrat in the 1880s. F.A. Chirak, a student at the Petersburg Academy of Arts, posed for the work.

"This artist may be called primarily a portrait painter of contemporary youth, whose nature, life, and character he understands profoundly and captures and presents. This is his main strength" (V. V. Stasov).

Ivan Nikolaevich Kramskoi

Mina Moiseev

Oil on canvas, 57 x 45 cm, 1882

Signed, upper left: IKramskoi 82 (letters I and K intertwined)
Inscribed, upper right: Siverskaia

The State Russian Museum, Leningrad

Inv. #2983

Accessioned from the Petersburg Academy of Arts in 1897

Mina Moiseev's portrait emerges as one of Kramskoi's best images of a peasant. Suffused with respect and sympathy for a simple man, the portrait played an important role in working out the problem of the positive, heroic figure in late nineteenth-century Russian art. ". . . What a tremendous wellspring," Kramskoi wrote about the simple folk. "All you need are ears to hear and eyes to see. . . ."

The work, which is a study for the painting *A Peasant with a Bridle,* 1883, located in the Kiev Museum of Russian Art, was created in the village of Siverskaia, near Petersburg. Kramskoi met Mina Moiseev there and often portrayed this peasant whose kind heart, folk wisdom, and lively character attracted the artist.

Ivan Nikolaevich Kramskoi

Portrait of V. N. Tretyakova

Oil on canvas, 92 x 70 cm, 1879

Signed, upper right: I. Kramskoi 79

The State Tretyakov Gallery, Moscow

Inv. #674

Acquired by P.M. Tretyakov in 1879 from the artist

Vera Nikolaevna Tretyakova (1844-1899), née Mamontov, was the wife of the gallery's founder, P.M. Tretyakov.

43

Ivan Nikolaevich Kramskoi

Ostrogozhsk, Voronezh Oblast 1837-1887 Petersburg

Portrait of the Poet N. A. Nekrasov

Ivan Nikolaevich Kramskoi attended the Petersburg Academy of Arts from 1857 to 1863, but he left before graduation as one of the artists in the "Rebellion of the Fourteen" who protested against the stagnant rules governing competitions at the Academy. After his departure, Kramskoi supported the creation of the Petersburg Artel of Artists, and he subsequently became its leader. He was also a founding member and an active participant in the Circle of the Itinerants, acting as the group's moral conscience and ideological inspiration. In 1869 Kramskoi received the title of a member of the Academy and afterwards enjoyed tremendous authority and influence among Russian artists. An outstanding portraitist and a prominent figure in Russian realist painting, Kramskoi moreover wrote art reviews in Petersburg, which today form a rich legacy on aesthetic issues and the history of Russian art.

"It is very likely that, were there no Kramskoi, there would not have been the ['Rebellion of the Fourteen'] on September 9, 1863, nor would there have been the manifestation of the new directions, nor, perhaps the very style since the talented young artists who were scattered and lacked firm convictions and a program would have dispersed and gone by unnoticed, and would have remained without influence, being constantly pressed and pursued by academism and every form of banality. Kramskoi's intellect and energy merged them all into a whole, giving their intentions a common, definite purpose . . ." (A.N. Benois, 1902).

Oil on canvas, 75 x 55 cm, 1877

Signed, lower left: I. Kramskoi 77 (letters I and K intertwined)

The State Tretyakov Gallery, Moscow

Inv. #669

Acquired by P.M. Tretyakov in 1877 from the artist

P.M. Tretyakov commissioned this painting from Kramskoi for his portrait gallery of prominent figures in Russian culture and art. Nikolai Alekseevich Nekrasov (1821-1877) was among the most popular poets of the nineteenth century and a highly acclaimed representative of critical realism in Russian poetry.

In his memoirs *Distant Near,* I.E. Repin recalled, ". . . His main and his largest works [I.N. Kramskoi's] are his portraits. . . . He created many portraits with such seriousness and poise."

Konstantin Alekseevich Korovin

Portrait of F. I. Chaliapin

Oil on canvas, 65 x 81 cm, 1911

Signed, lower right: Korovin 1911

The State Russian Museum, Leningrad

Inv. #4332

Accessioned from the collection of E.M. Tereshchenko in 1918

Korovin and Fedor Ivanovich Chaliapin (1873-1938) were friends for many years. This portrait was completed in France during his vacation in a little health resort in the town of Vichy. The actress N.I. Komarovskaia wrote that Korovin painted his friend "seated in a low wicker chair, wearing a white suit. Roses are on the table; there is red wine in the glasses. The portrait amazingly conveys the sense of power, freshness, and health exuded by Chaliapin's figure that morning."

The painting's beautiful, silvery background calls to mind Korovin's words about Vichy: "What a remarkable quality of light there is here!"

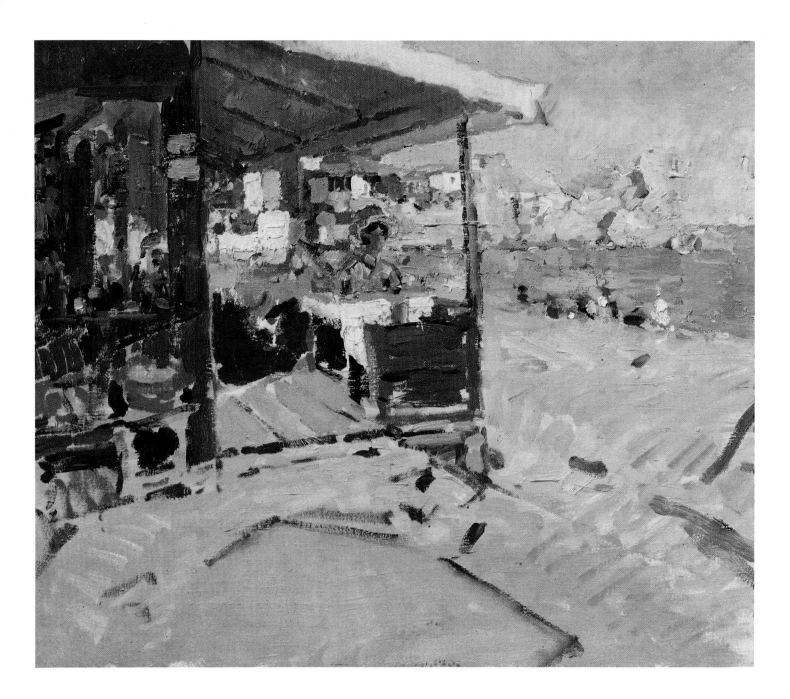

Konstantin Alekseevich Korovin

Moscow 1861-1939 Paris

On the Seashore in the Crimea

After he attended the Petersburg Academy of Arts in 1882 and studied at the Moscow School of Painting, Sculpture, and Architecture with A.K. Savrasov and V.D. Polenov from 1875 to 1886, Konstantin Alekseevich Korovin taught at the School for seventeen years (1901-1918) as well as at the State Free Art Studios (1918-1919). Korovin was a long-term member of several art associations, including the Abramtsevo Art Circle, World of Art (1899-1903), and the Union of Russian Artists (1903-1922). He participated in the exhibitions of the Circle of the Itinerants from 1889 to 1899, the Moscow Society of Art Lovers (periodically between 1889 and 1911), and 36 Artists (1901-1902). In 1905 he received the title of a member of the Academy, and five years later he was awarded the Legion of Honor for his creation of the architectural plans and decorative panels for the 1910 World's Fair in Paris.

In addition to painting landscapes, portraits, genre scenes, and still lifes, Korovin worked in the decorative and applied arts. He designed sets for the Bolshoi Theater and private opera in Moscow and for the Marinsky and Alexander Theaters in Petersburg before he moved to Paris in 1923. Korovin is remembered in Russian painting as a particularly talented representative of Impressionism.

Oil on canvas, 53.8 x 64.8 cm, 1909

The State Tretyakov Gallery, Moscow

Inv. #1512

Acquired by the Council of the Gallery in 1910 from the artist

A.N. Benois wrote of K.A. Korovin: "This was our first 'Impressionist' — he was among the first to have dared composing his pictures without any preconceived subject, . . . and his very devices had such spontaneity and simplicity about them that even the most daring artist of the older generation would never have let himself use them [in his pictures], and that includes even Repin or Surikov."

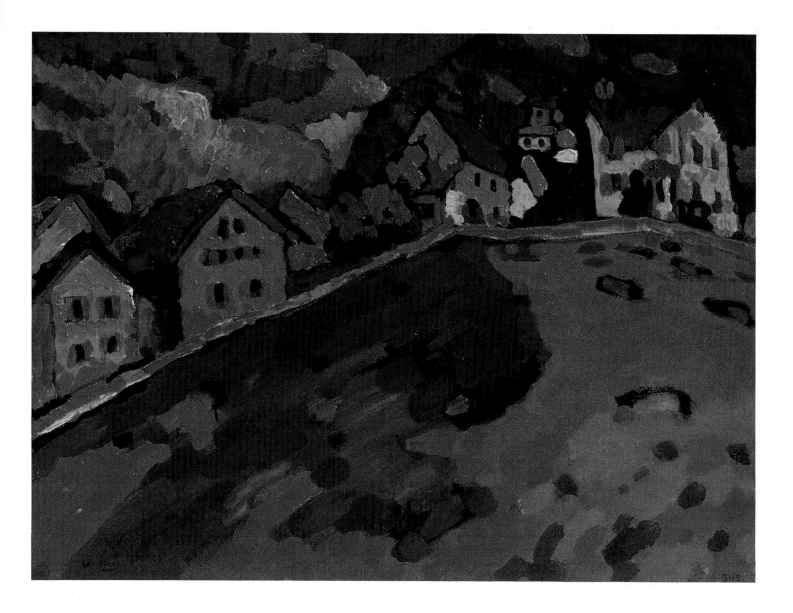

Vasilii Vasilievich Kandinsky

Moscow 1866-1944 Neuilly-sur-Seine, near Paris

The Summer Landscape

The Russian artist Vasilii Vasilievich Kandinsky attended the school of Anton Azbé in Munich from 1897 to 1899 and then studied with Franz von Stuck at the Munich Academy of Arts. A world traveler, Kandinsky lived in Munich from 1907 to 1914, returned to Moscow until 1921, moved to Germany until 1933, and then settled permanently in France. One of the founders of the Munich Arts Association, he also was instrumental in forming the artists' groups "Phalanx" (1901), the "New Association of Artists" (1909), and the "Blue Rider" (1911), in addition to the Museum of Pictorial Culture (1919) and the Institute of Artistic Culture (1920). Kandinsky taught at the State Free Art Studios-Higher Art and Technical Studios (Vkhutemas) in Moscow for three years (1918-1921) and at Moscow University in 1920. After he moved to Germany, he was an instructor at the architectural and art school of the Bauhaus in Weimar from 1921 to 1925 and then for another eight years in Dessau (1925-1933).

Although associated with the German school of painting, particularly German Expressionism, Kandinsky's early works were mainly landscapes and symbolic-decorative motifs. He then turned his attention to creating non-objective "improvisations" and "compositions," which he numbered. Kandinsky's theory of "absolute painting" became a basis of abstract art.

Oil on paperboard, 33 x 45 cm, 1909

Signed, lower left: Kandinsky
Verso, dated, signed, and inscribed: 1909 Kandinsky Studio #5

The State Russian Museum, Leningrad

Inv. #1634

Accessioned from K.A. Korovin's collection in 1920

This landscape was composed in the small town of Murnau, located in Upper Bavaria at the foot of the Alps, where Kandinsky then lived. During this period, Kandinsky worked in a style common to many of his contemporary German Expressionists, which was characterized by tension, heightened color, and dynamic pictorial techniques. Motifs from nature emerge according to the character of the pliable material used and are thus an expression of the artist's creative credo transformed by the strength of his temperament. Years later, Kandinsky himself defended the artist's right to choose freely his expressive means, which were controlled only by the "principles of inner necessity."

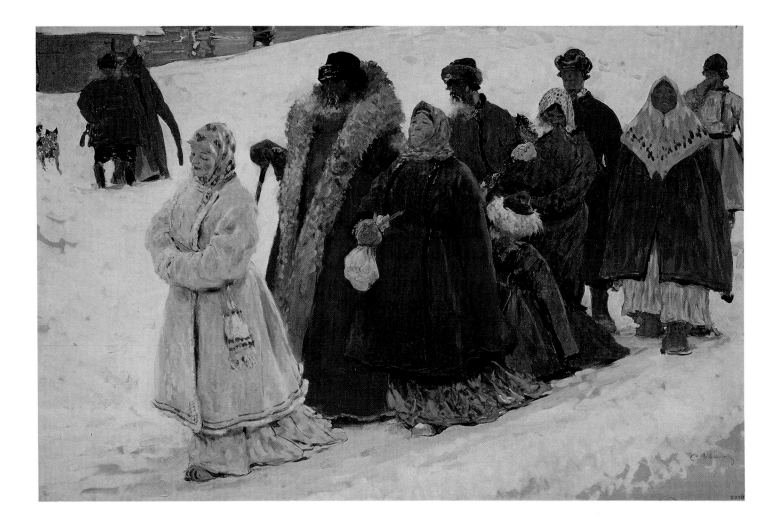

Sergei Vasilievich Ivanov

Ruza, Moscow Province 1864-1910 village of Svistukha, Moscow Province.

The Family

Between his years of study at the Moscow School of Painting, Sculpture, and Architecture (1878-1882 and 1884-1885), where he was instructed by I. M. Prianishnikov and E. S. Sorokin, Sergei Vasilievich Ivanov attended the Petersburg Academy of Arts. He taught at both the Stroganov Arts-Industrial School (1899-1906) and the Moscow School of Painting, Sculpture, and Architecture (1900-1910). A member of the Circle of the Itinerants from 1889 and of the Academy of Arts from 1905, Ivanov was also one of the founders of the Union of Russian Artists in 1903. Beyond his landscapes, portraits, and book illustrations, his paintings addressed themes of revolution in Russian history as well as everyday life.

Ivanov, a leading representative of the Russian realist school, continued the democratic traditions of critical realism expounded in the second half of the nineteenth century. He devoted much of his attention to finding uniquely national themes for his works.

Oil on paperboard, 67 x 103 cm, 1910

Signed, lower right: S. Ivanov

The State Russian Museum, Leningrad

Inv. #4388

Accessioned from the Petersburg Academy of Arts in 1925

The idea for this painting came to Ivanov as early as 1904 when he executed a preliminary version (location now unknown). The artist returned to this subject on more than one occasion; paintings bearing the same title, dated 1906 and 1907, as well as more than fifty preparatory sketches and studies demonstrate the sequential development of his concept.

When the 1907 version (now owned by the State Tretyakov Gallery) appeared at the Union of Russian Artists exhibition that year, it elicited a number of critical responses. Apparently the artist himself was not satisfied with the work either, and in 1910 he created a smaller version that was more accomplished compositionally and undoubtedly better as a painting. This work embodied Ivanov's perceptions of mores and life in old, patriarchal Rus. In his love for the history of Russian culture, he attempted to find the origins of the nation's uniqueness through themes about life in a seventeenth-century Russian village, the age preceding Peter the Great's revolutionary reforms. In addition to Ivanov, many artists at the turn of the century shared these interests, particularly his associates in the Union of Russian Artists.

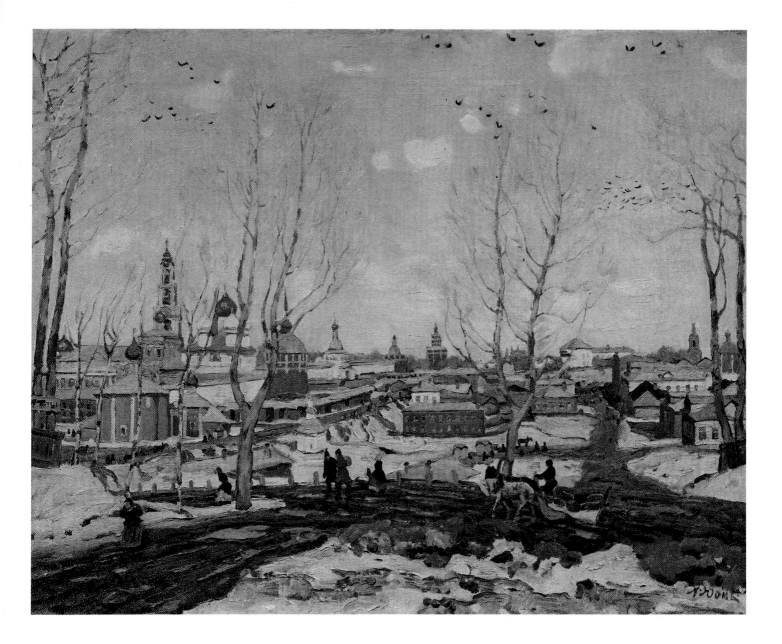

Konstantin Fedorovich Iuon

Moscow 1875-1958 Moscow

Spring at the Trinity Monastery

At the Moscow School of Painting, Sculpture, and Architecture, which he attended from 1892 to 1898, Konstantin Fedorovich Iuon was instructed by K. A. Savitskii, A. E. Arkhipov, N. A. Kasatkin, and K. A. Korovin. After graduation, he worked in the studio of V. A. Serov (1898-1900) and lived in Moscow. He later taught at his own studio for seventeen years, from 1900 to 1917, with fellow artist I. O. Dudin; at the Leningrad Institute of Painting, Architecture, and Sculpture (1934-1935); and then at the Moscow Art Institute (1952-1955). Iuon participated in the exhibitions sponsored by the Itinerants in 1900 and by World of Art (1903, 1906), and he was a member of the Union of Russian Artists for twenty years (1903-1923) as well as a life member of the *Salon d'Automne* in Paris. From 1925 on he held a membership in the Association of Artists of Revolutionary Russia. Iuon was made chief painter of the State Academic Maly Theater (MKHAT) in Moscow (1945-1947), director of the Research Institute of Theory and History of Fine Arts of the Academy of Arts of the USSR (1947), and three years later, People's Artist of the USSR.

Beyond producing landscapes, portraits, genre scenes, and paintings on historical-revolutionary themes, Iuon worked in the theater and wrote many articles and books on art. In his own art, Iuon presented motifs common to the Russian provinces, using their distinctive historical-national characteristics in scenes of everyday life and richly painting landscapes in a style influenced by Impressionism.

Oil on canvas, 70 x 90 cm, 1911

Signed, lower right: K. Iuon

The State Russian Museum, Leningrad

Inv. #1808

Accessioned from the Committee on Art Affairs with the Council of Ministers of the Soviet Union in 1950

The artist reminisced, ". . . The unusual color of folk architecture gripped and astounded me most of all. I was struck by the colorful outlines of the paints and forms of the ancient churches and belfries, by the variegated, cheerful, and naively provincial colors of the houses. . . . These picturesque towns are where I found a theme for my painting. . . ."

Iuon devoted a great deal of his attention to painting the Trinity-Sergius Monastery [a combination church and fortress], an outstanding monument of Russian architecture in the Sergiev Posade (now Zagorsk) near Moscow.

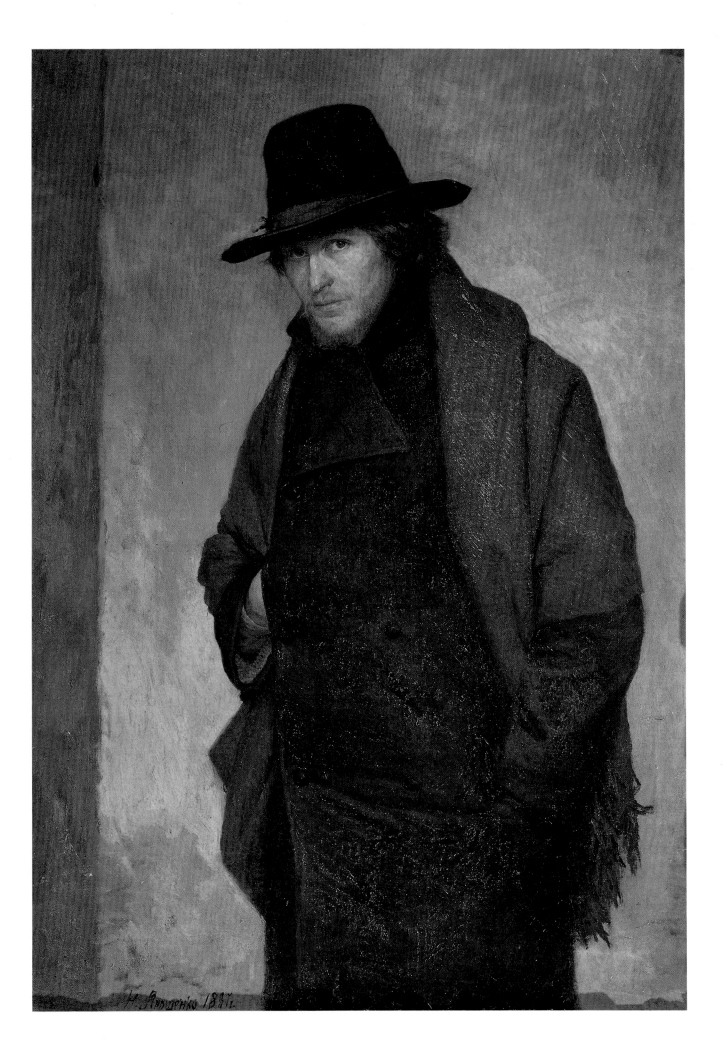

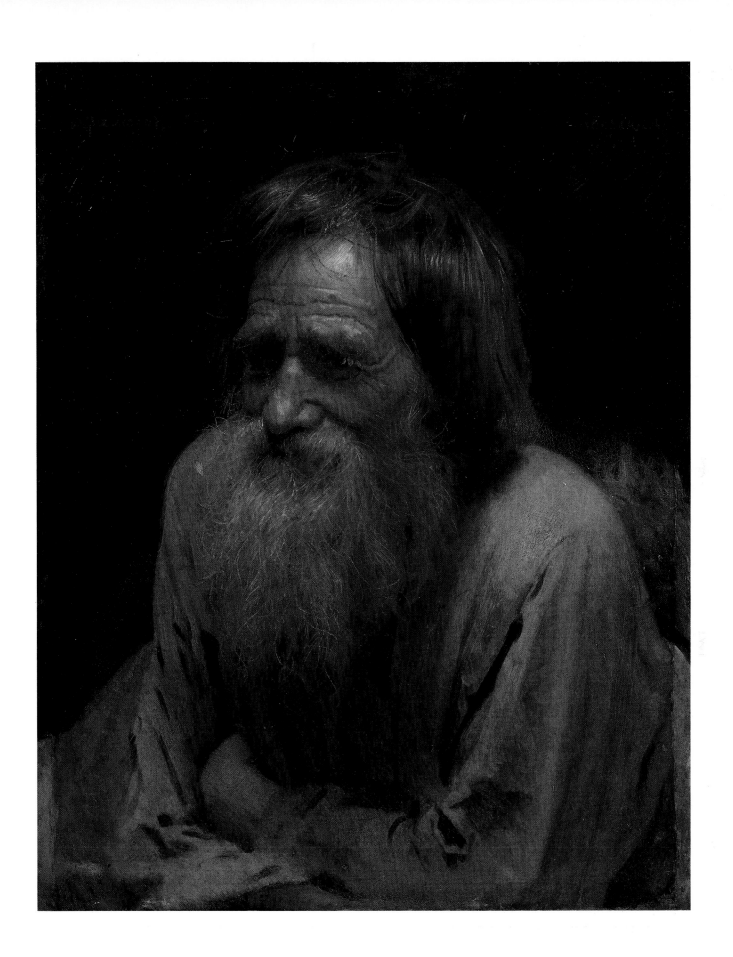

Arkhip Ivanovich Kuindzhi

Mariupol (now Zhdanov) 1842?-1910 Petersburg

Lake Ladoga

Despite his lack of a formal art education, Arkhip Ivanovich Kuindzhi became a professor and head of the landscape studio (1894-1897) in the Higher Art School affiliated with the Petersburg Academy of Arts. Prior to this, he worked for a year (1865-1866) in the general art studio of I.K. Aivazovskii in Theodosia and joined the Circle of the Itinerants (1875-1879), exhibiting with the group from 1874. He also participated in the exhibitions held by the Academy, having become an active member in 1893, and organized a number of exhibitions of his own work. Later Kuindzhi urged the creation of the Association of Artists, which remained a vital artists' group from 1908 to 1931 and eventually bore his name.

As a landscape painter who lived in the Crimea and Petersburg, Kuindzhi was one of several outstanding artists who took part in the formation of a national school of Russian landscape painting during the second half of the nineteenth century; he represents its romantic line. An emotionally charged interpretation of nature, generalized forms, intense colors and their heightened contrast, a vividly expressed decorative composition, and a search for the pictorial are all characteristic features of his art. Kuindzhi the teacher nurtured a glittering group of landscape artists, which included Nikolai Roerich, Arkadii Rylov, and Konstantin Bogaevskii, among others.

Oil on canvas, 79.5 x 62.5 cm, 1870

Signed, lower right: A.K.

The State Russian Museum, Leningrad

Inv. #843

Accessioned from the A.I. Kuindzhi Society, Leningrad, in 1930

The painting dates from an early stage of the artist's work. Based on Kuindzhi's recollections of his trip to the island of Valaam, the painting marked the beginning of a series of northern landscapes. Besides conveying a generally heightened and agitated state of nature, the artist also concentrated on recreating the effect of light passing through clear water, revealing the rocky bottom of a lake's shore. Kuindzhi, in this very picture, was the first to use this motif in a Russian painting.

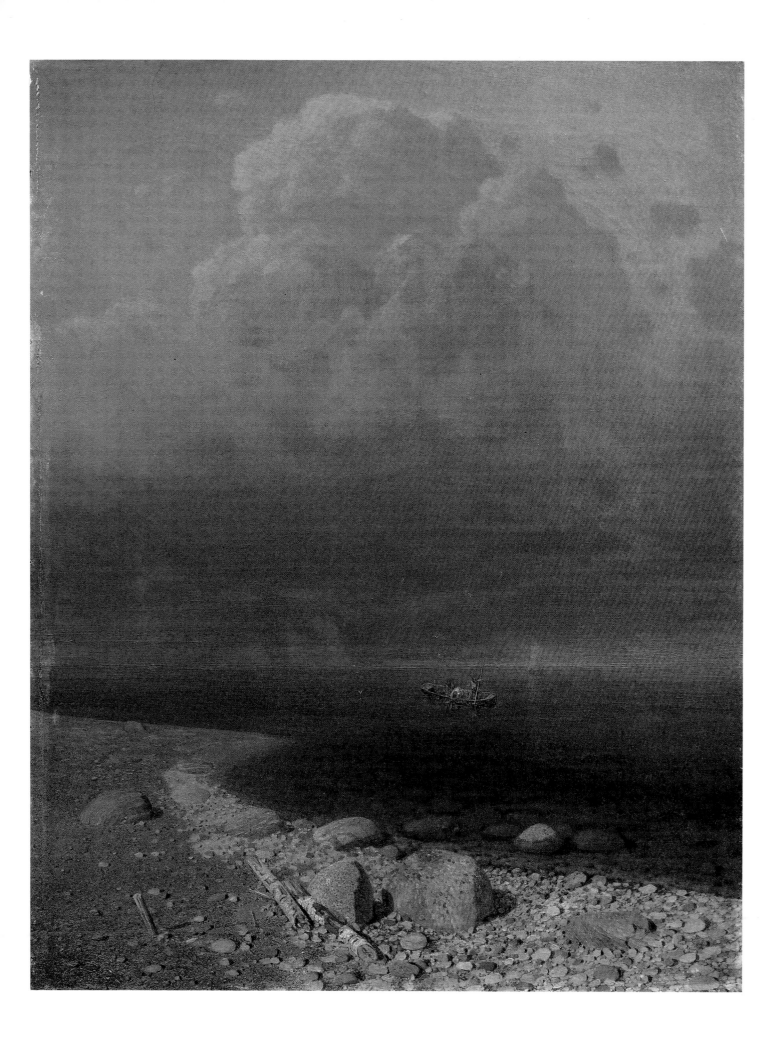

Arkhip Ivanovich Kuindzhi

Moonlight in Winter Forest

Oil on paper on canvas, 39 x 53.5 cm, 1898-1908

The State Russian Museum, Leningrad

Inv. #1514

Accessioned from the A. I. Kuindzhi Society, Leningrad, in 1914

In his later work, Kuindzhi searched for new, expressive ways of depicting nature. After he stopped participating in exhibitions and closed his studio to visitors, Kuindzhi devoted himself to creative experimentation. The problems of colors and their contrasts, and uncommon moments in nature particularly captivated him. Small studies comprise a significant portion of his work of the 1890s into the 1900s. They are distinguished by a romantically heightened interpretation of the subject and by decorative solutions.

The extremely decorative effect of moonlight shining on snow adds structure to this work as well. Its generalized forms and softened contours, alternating between lit areas and shadows, cast a mysterious image of a winter night in the forest.

Isaak Ilych Levitan

village of Kibarty (now Kibartai Lithuanian Soviet Socialist Republic) 1860-1900 Moscow

The Birch Grove

A resident of Moscow, Isaak Ilych Levitan studied with A. K. Savrasov and V. D. Polenov at the Moscow School of Painting, Sculpture, and Architecture from 1873 to 1885. His travels throughout Russia and Europe — Crimea (1886, 1899), Finland (1896), and Italy, France, and Switzerland in the 1890s — were crucial to his art. Levitan became fascinated with the French landscape painting of the Barbizon School and later with Impressionism. Trips to the Volga in 1887, 1888, 1889, and 1891 played an important role in his artistic development, for his Volga landscapes defined his creative manner and brought him fame and glory. Levitan began taking part in the exhibitions sponsored by the Circle of the Itinerants in 1884, becoming a member in 1891. From 1898 to 1900 he headed the department of landscape painting at the Moscow School of Painting, Sculpture, and Architecture, and in 1898 he was awarded membership in the Academy. Levitan, who was closely associated with Chekhov, well represents Russian landscape painting in the nineteenth century.

"Levitan was neither a Barbizon nor a Dutch artist, nor was he an Impressionist, nor all of that taken together. Levitan was a Russian artist, but he was Russian for other reasons than one would be if one were to create Russian motifs out of some patriotic principles. He was Russian for the reason that he understood the hidden beauty of Russian nature, its hidden meaning" (A. N. Benois, 1902).

"Before Levitan, no one approached such an amazing simplicity and clarity of motif as he has recently done. I don't really know whether anyone will approach them after him" (A. P. Chekhov).

Oil on paper on canvas, 28.5 x 50 cm, 1885-89

Signed, lower left: I. Levitan

The State Tretyakov Gallery, Moscow

Inv. #15511

Acquired in 1935; earlier in the collection of A. P. Langovoi, Moscow

This image stands out as one of the brightest and most impressionistic works by the young I. I. Levitan, who, as A. P. Chekhov remarked, dreamed of "nature's smile."

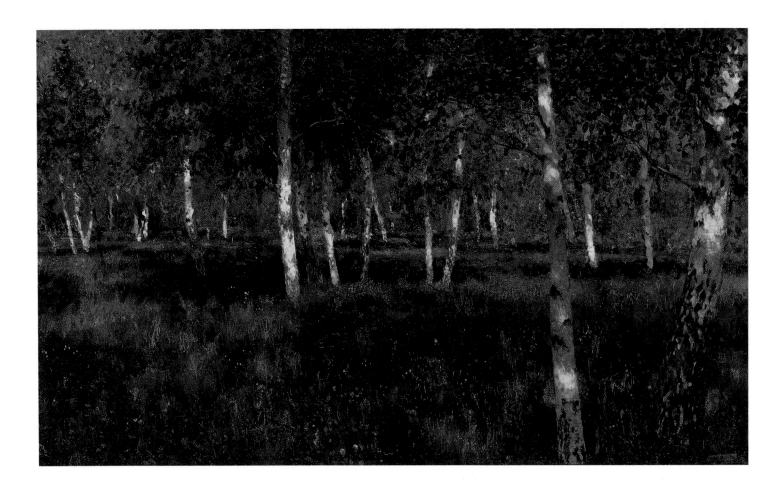

Isaak Ilych Levitan

Quiet Monastery

Oil on canvas, 87.5 x 108 cm, 1890

Signed, lower right: I. Levitan 1892

The State Tretyakov Gallery, Moscow

Inv. #584

Accessioned by the Tretyakov Gallery in 1970;
earlier in the collection of N.S. Golovanov,
Moscow

One of the most popular works by I.I. Levitan,
this painting strikingly expresses his search for
beauty and harmony in the real world.

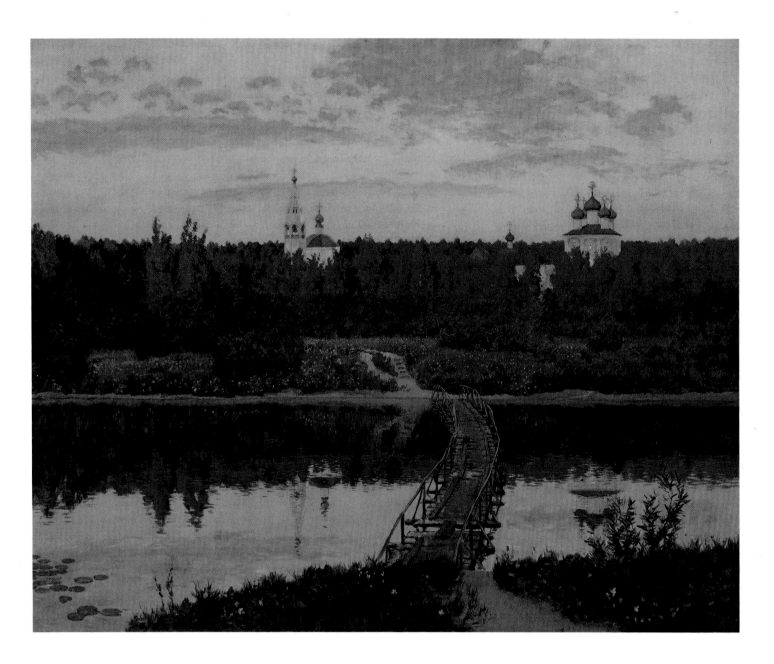

Isaak Ilych Levitan

Silence

Oil on canvas, 96 x 128 cm, 1898

Signed, lower right: I. Levitan

The State Russian Museum, Leningrad

Inv. #4276

Accessioned from the State Museum Fund in 1927;
earlier in the collection of I. A. Morozov, Moscow

The completely peaceful, poetic work was executed during Levitan's late creative period, when he continued in the traditions of the realist school of landscape painting of the late nineteenth century. At the same time, however, it anticipated new directions in painting, achieving greater generalization and artistic brevity, which gave his later images a particular expressiveness. As he turned to the simplest and most unassuming motifs in rural nature, Levitan "reveals that which is humble and innermost within every Russian landscape — its soul, its charm" (M.V. Nesterov).

Vladimir Egorovich Makovskii

The Explanation

Oil on canvas, 53 x 39.5 cm, 1889-91

Signed, lower right: V. Makovskii 1889-91

The State Tretyakov Gallery, Moscow

Inv. #631

Acquired by P.M. Tretyakov in 1891 from the artist

This characteristic example of V. E. Makovskii's genre painting of the end of the 1880s well represents the period of the master's peak maturity. The figures' poses, gestures, and facial expressions draw the viewer's attention to the beauty of the sun-drenched interior of a country summer home.

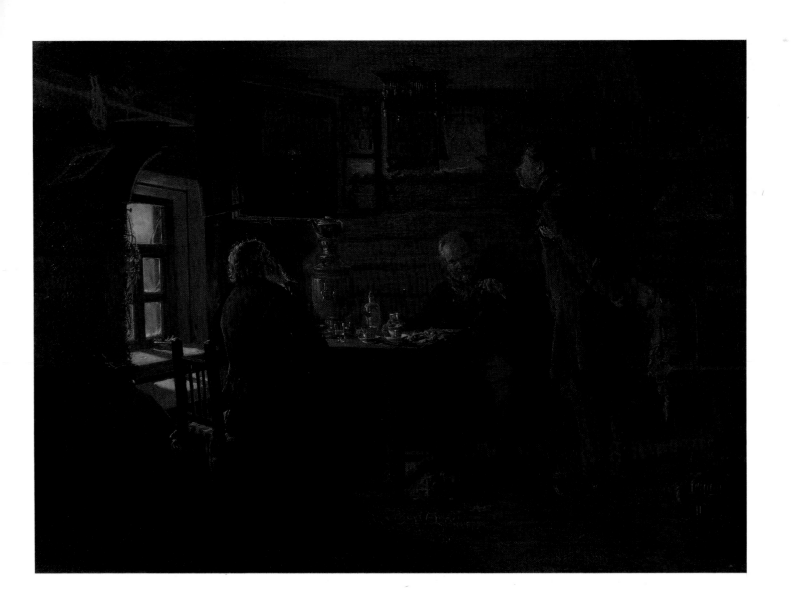

Vladimir Egorovich Makovskii

Moscow 1846-1920 Petrograd (Leningrad)

A Gathering of the Nightingale Watchers

Vladimir Egorovich Makovskii painted primarily genre scenes. His works, based on the serious and careful observation of the lives of simple people, represent one of the more typical examples of Russian genre painting of the second half of the nineteenth century. From 1861 to 1866 Makovskii studied with E. S. Sorokin and S. K. Zarianko at the Moscow School of Painting, Sculpture, and Architecture. (He taught there twenty years later, from 1882 to 1894.) In 1873 he became a member of the Academy and joined the Itinerants' art exhibitions, eventually becoming one of the Circle's leaders and thus linking his creative life with the group. Makovskii headed from 1894 through 1916 the genre painting studio affiliated with the Higher Art School of the Petersburg Academy of Arts. A painter of genre scenes and portraits, he also illustrated the literary works of N.V. Gogol.

"Vladimir Makovskii — one of the best and most fundamental of Russian artists. . . . He is a worthy friend, successor and follower of Perov. . . . His essential mastery and skill have always manifested themselves in the depiction of city life" (famed Russian art critic V. V. Stasov).

Oil on canvas, 55 x 76 cm, 1872-73

The State Tretyakov Gallery, Moscow

Inv. #595

Acquired by P.M. Tretyakov from the artist

"Makovskii is an example of a genre painter who was interested in everything, all classes of society. . . . He was not lazy about 'walking through life,' which he depicted with uncommon interest and tremendous mastery" (B. V. Ioganson, People's Artist of the USSR).

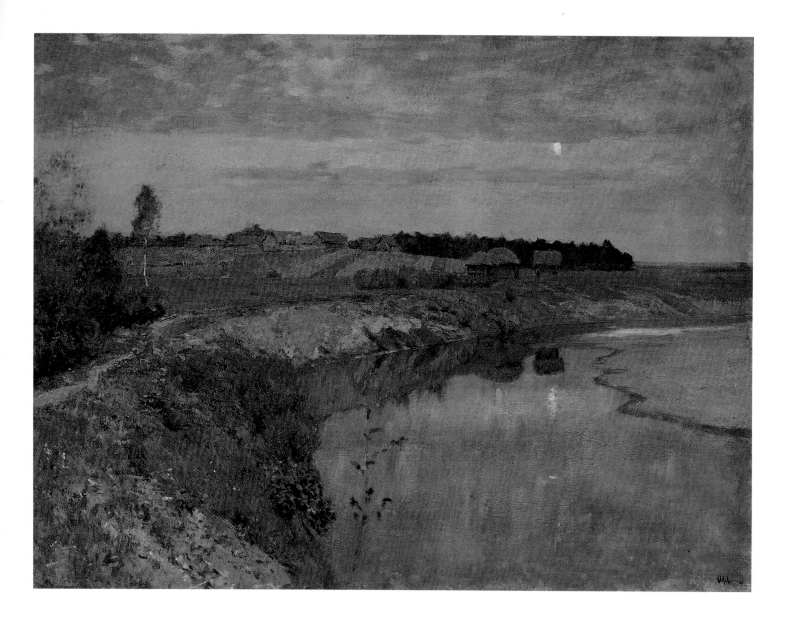

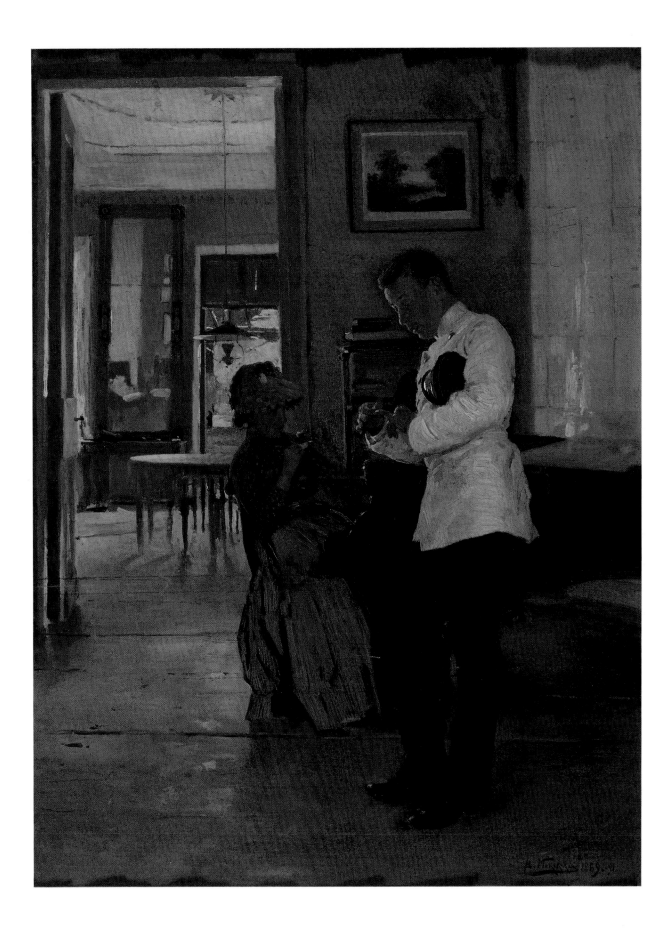

Vasilii Maksimovich Maksimov

village of Lopino, near Novaia Ladoga 1844-1911 Petersburg

It's All in the Past

The son of a peasant, Vasilii Maksimovich Maksimov was first exposed to the art profession when, as a youth, he worked in icon workshops in Petersburg (1855-1862). Subsequently, he studied at the Petersburg Academy of Arts from 1863 to 1866, receiving the title of member in 1878. From 1866 on, he lived alternately in Petersburg and in the village of Shubino in the Tver Province. A well-known painter of genre scenes, Maksimov actively participated in the Circle of the Itinerants' exhibitions as early as 1872.

". . . For him people and villages are not a collection of models and dead objects that only need to be copied carefully. He . . . knew what he portrayed, and for this reason his complex scenes are not by their nature casual snapshots but typical social documents" (A. N. Benois, 1902).

Oil on canvas, 72 x 93.5 cm, 1889

Signed, lower right: 1889 V. Maksimov

The State Tretyakov Gallery, Moscow

Inv. #589

Acquired by P. M. Tretyakov in 1889 from the artist

". . . Maksimov painted a picture called *It's All in the Past:* an old lady of the manor is sitting by her porch, dreaming . . . in an old armchair . . . while her housekeeper sits on a step knitting. Two marvelous figures, wonderfully true and alive" (from a letter by the artist V. D. Polenov to his wife on February 21, 1889).

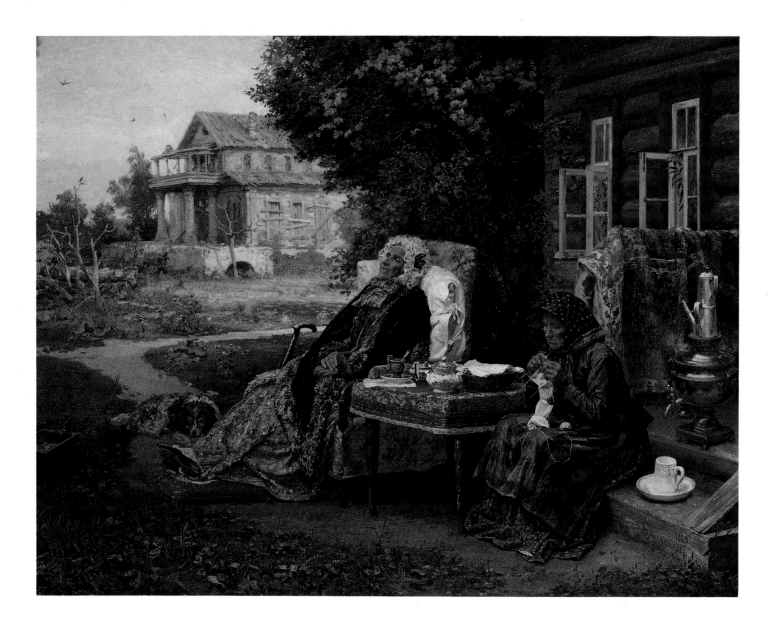

Kazimir Severinovich Malevich

near Kiev 1878-1935 Leningrad

Apple Blossoms

Kazimir Severinovich Malevich received his early artistic training from the Kiev Drawing School (1895-1896), the Moscow School of Painting, Sculpture, and Architecture (1904-1905), and in the studio of F.I. Rerberg in Moscow (1905-1910). In addition to being a member of the Union of Youth association from 1910 to 1914, Malevich took part in numerous exhibitions, including *Jack of Diamonds* (1910), *Donkey Tail* (1912), *Target* (1913), *Tramway V* (1915), and *0.10* (1915-1916). He founded the Establishers of the New Art (UNOVIS) in Vitebsk in 1920 while he taught at the People's Art School there from 1919 to 1922. (Before that, he briefly conducted courses at the State Free Art Studios in Moscow in 1918.) The artist later served as director and professor of the Institute of Artistic Culture in Petrograd-Leningrad from 1923 to 1927.

A prominent figure in the Russian avant-garde, Malevich first painted in an Impressionist style, then experimented with Fauvism before he became one of the founders and leading masters of Russian cubo-futurism. He originated the art theory of "suprematism," one of the diverse aspects of non-objective art. During the early phases of his creative activity, Malevich produced portraits, landscapes, and genre scenes before he concentrated on non-objective "suprematist" compositions. In his later years he returned to figurative art, primarily portraiture. Malevich is also acknowledged as the author of numerous theoretical works on the problems of pictorial form, color, and artistic perception.

Oil on canvas, 55 x 70 cm, 1904

Signed, lower right: K. Malevich
Inscribed, below signature: 904

The State Russian Museum, Leningrad

Inv. #1622

Accessioned from the artist in 1933

Characteristic of his early impressionistic works, Malevich painted this while under the influence of the French Impressionists and Post-Impressionists, in particular Claude Monet, Georges Seurat, and Paul Signac. Already in this early landscape, however, the artist is above all interested in the expressive possibilities of color and the structure of painting, concerns that continued to attract his attention in both practice and theory.

"A painter looks at the world not in terms of objects — forests, rivers, per se — but in terms of pictorial qualities. The painting grows by means of woods, a mountain, a stone, etc. In the eye of the artist, all varieties, characteristics and inherent qualities are nothing more than aesthetic differences" (Malevich).

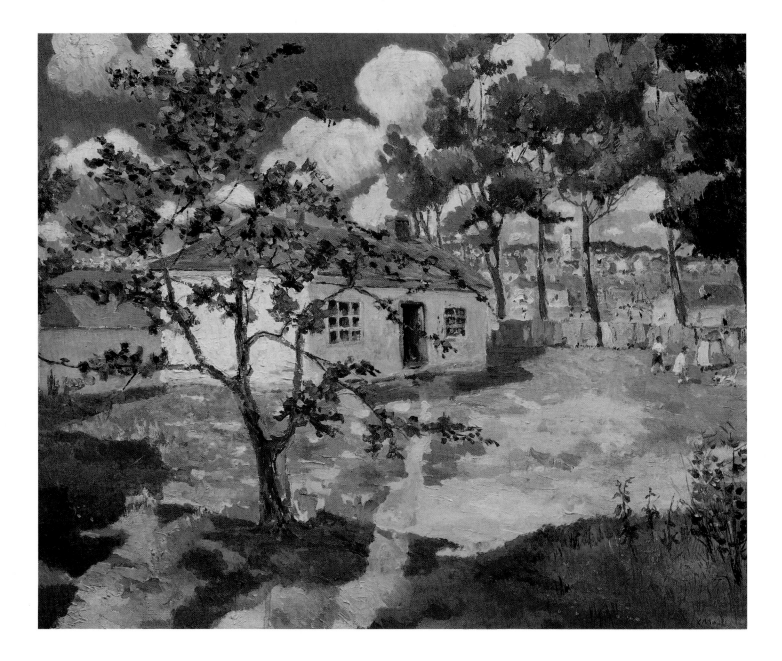

Filipp Andreevich Maliavin

village of Kazanki (now Orenburg Oblast) 1869-1940 Nice, France

Reading a Book

Filipp Andreevich Maliavin's early art education was based on the production of icons. As a young man, he worked for seven years in the icon workshops of the Mt. Athos Monastery in Greece (1885-1892) before he received instruction from I. E. Repin at the Petersburg Academy of Arts from 1892 to 1899. He later became known as a graphic artist and a painter of genre scenes and portraits. Maliavin lived primarily in Petersburg, where he was a member of the Union of Russian Artists and headed the Riazan State Free Studio from 1919 to 1921, before he settled in France the next year.

Oil on canvas, 106.5 x 72 cm, 1895

Signed, upper right: F. Maliavin

The State Tretyakov Gallery, Moscow

Inv. #1570

Acquired from the artist in 1896; gift of P. M. Tretyakov in 1896

The artist here portrays his sister, Aleksandra Andreevna Maliavina (1873-1903). Born the son of a peasant, Maliavin tried throughout his creative life to reflect in art the deeply rooted and highly expressive aspects of the Russian peasantry's spontaneous, spiritual life.

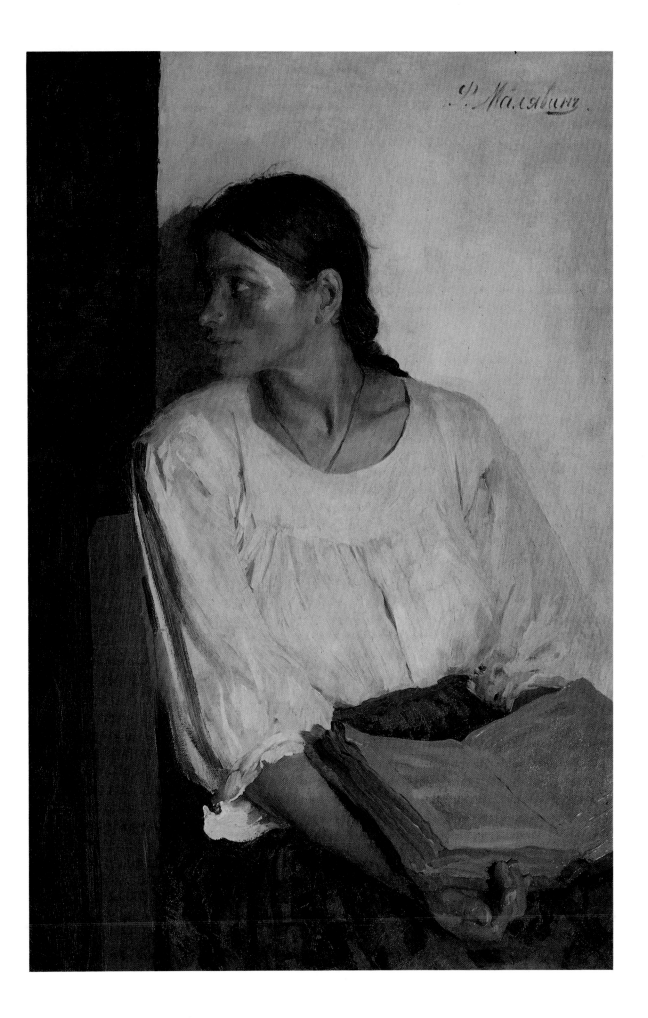

67

Mikhail Vasilievich Nesterov

Ufa 1862-1942 Moscow

Hermit

Between his studies with V.G. Perov, A.K. Savrasov, and I.M. Prianishnikov at the Moscow School of Painting, Sculpture, and Architecture (1877-1881 and 1884-1886), Mikhail Vasilievich Nesterov attended the Petersburg Academy of Arts from 1882 to 1884. He achieved membership in the Academy in 1898. In addition to participating in the Abramtsevo Art Circle and being a founding member of the Union of Russian Artists, Nesterov included his works in the exhibitions of World of Art (1899-1901) and 36 Artists (1901). Beginning in 1896, he joined the Circle of the Itinerants' art exhibitions. He executed murals in St. Vladimir's Cathedral in Kiev, in the Cathedral of the Resurrection in Petersburg, and in the Marfo-Marinsky Monastery in Moscow. A realist painter, Nesterov concentrated on religious-symbolic subjects in his early works. Nesterov was also recognized in 1942 as a distinguished figure in art in the Russian Soviet Federal Republic for his work in the areas of portraiture, landscape painting, and genre scenes. He was acknowledged as one of the outstanding masters of Soviet portrait painting.

Oil on canvas, 91 x 84 cm, 1888

Signed, lower right (with a later date): M. Nesterov 90

The State Russian Museum, Leningrad

Inv. #4337

Accessioned from S.P. Diaghilev in 1909; earlier in the collection of I.S. Ostroukhov, Moscow

The theme of hermits, monks, and others who left the life of this world for that of solitude and peace of mind recurs throughout the career of Nesterov, who set aside a special place for the moral-ethical problems of art. *Hermit,* one of the artist's first pictures on this subject, is the initial version of the larger painting (the figure is full length) which P.M. Tretyakov acquired from M.V. Nesterov and which still hangs in the State Tretyakov Gallery.

In one of his letters, Nesterov himself described the genesis of the first version of this painting. "In '88 I started work on the *Hermit* in Ufa. My canvas turned out to be poor [quality], and I was no better to boot. The painting had to be abandoned and started anew on another piece of canvas. The second version turned out fine and ended up in the Tretyakov Gallery. As for the first version, having taken it out of the subframe, I let it get lost in my studio, where Ostroukhov picked it up. Many years later Diaghilev traded a 'Kramskoi' for the *Hermit*." Despite the artist's casual attitude toward his own painting, *Hermit* is considered to be clearly one of young Nesterov's creative successes, a work of depth and poetry.

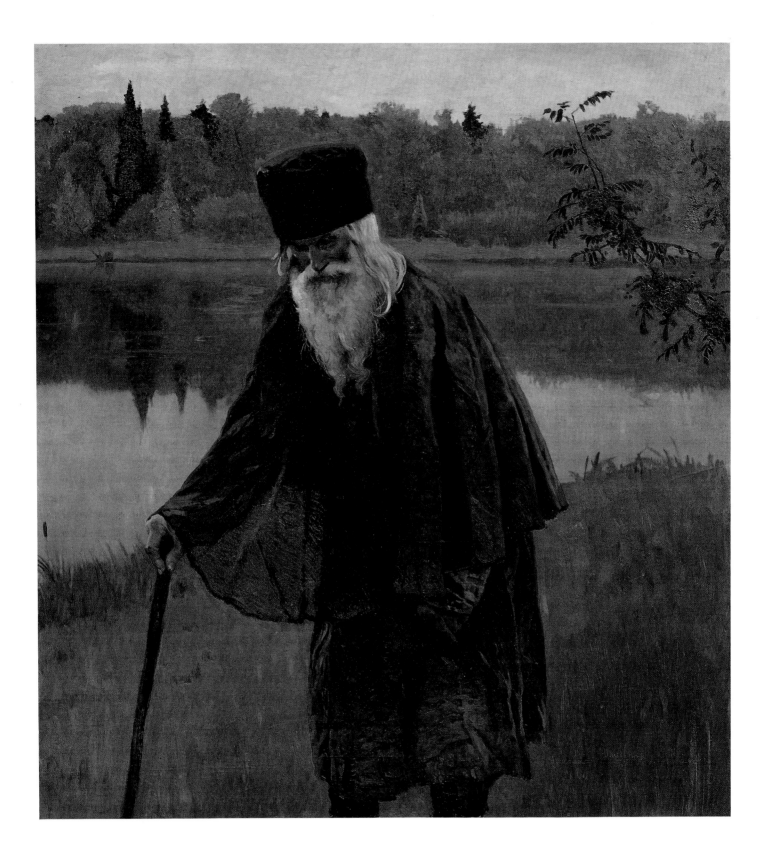

Ilya Semenovich Ostroukhov

Moscow 1858-1929 Moscow

Golden Autumn

Although Ilya Semenovich Ostroukhov did not complete his formal art education, he began painting as an adult in 1880 under the guidance of A.A. Kiselev, I.E. Repin, and P.P. Chistiakov and joined the Circle of the Itinerants in 1891. Ostroukhov lived in Moscow but traveled abroad frequently. A friend of P.M. Tretyakov and a sponsor of the Tretyakov Gallery, Ostroukhov served on the Gallery's council from the time of its founder's death in 1898 until 1913. Recognized in Moscow as an art collector himself, Ostroukhov was among the first to acquire Ancient Russian art. The artist also established the Museum of Icons and Art, which existed until 1929, when it became a part of the State Tretyakov Gallery. He was a prominent representative of the Moscow followers of the Russian school of lyrical painting.

Oil on canvas, 48.2 x 66.3 cm, ca. 1887

Signed, lower right: I. Ostroukhov

The State Tretyakov Gallery, Moscow

Inv. #1467

Acquired by P.M. Tretyakov in 1887 from the artist

"In 1887 for the first time Ostroukhov drew serious attention to himself with his remarkable pictures: *Golden Autumn* and *Spring* are among the predecessors that come the closest of all in spirit and time to Levitan" (A.N. Benois, 1902).

Vasilii Grigorievich Perov

Portrait of the Playwright A. N. Ostrovskii

Oil on canvas, 103.5 x 80.7 cm, 1871

Signed, lower left: V. Perov 1871

The State Tretyakov Gallery, Moscow

Inv. #385

Acquired by P.M. Tretyakov from the artist

This portrait of Aleksander Nikolaevich Ostrovskii (1823-1886), a leading realist playwright famous for exposing "the kingdom of darkness" of the ignorant merchant class, was commissioned by P.M. Tretyakov and completed by V.G. Perov for Tretyakov's gallery of portraits of prominent figures of Russian culture and art. It is considered one of the most significant portraits Perov painted.

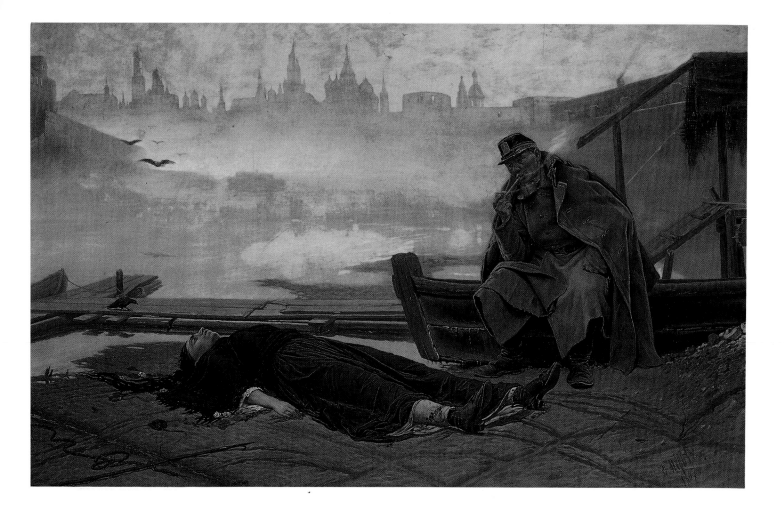

Vasilii Grigorievich Perov

Tobolsk 1834-1882 village of Kuzminki, near Moscow

A Drowned Woman

Vasilii Grigorievich Perov received his initial art training in the provincial Arzamass School of Art run by A.V. Stupin, who inculcated his students with his early, and in many ways still naive, realist skills. From 1853 until 1861, Perov studied at the Moscow School of Painting, Sculpture, and Architecture. After that he lived in Paris (1862-1864), studying the works of the Old Masters while enjoying life in the outlying areas of the city. Perov returned to Moscow in 1864, where he headed a group of young artists-realists and became a founding member of and an active figure in the Circle of the Itinerants. In 1866 he received the title of member of the Petersburg Academy of Arts. A leading painter of genre scenes and portraits in the 1860s and 1870s, Perov exercised an enormous influence on the development of Russian realism in the second half of the nineteenth century.

"... What a talent! What an imposing, independent figure! What a marvelous choice of subjects! What an eye and a talent for observation! Such a rich gallery of types this original Siberian has brought into our art" (V.V. Stasov).

Oil on canvas, 68 x 108 cm, 1867

Signed, lower right: V. Perov 1867

The State Tretyakov Gallery, Moscow

Inv. #365

Acquired by P.M. Tretyakov in 1885 from N.A. Pushkevich

This is one of the central works of the art legacy of V.G. Perov, whose art was permeated with a passionate abhorrence of social evil and injustice and with compassion for the dramatic fate of poor people and all the "humiliated and the injured."

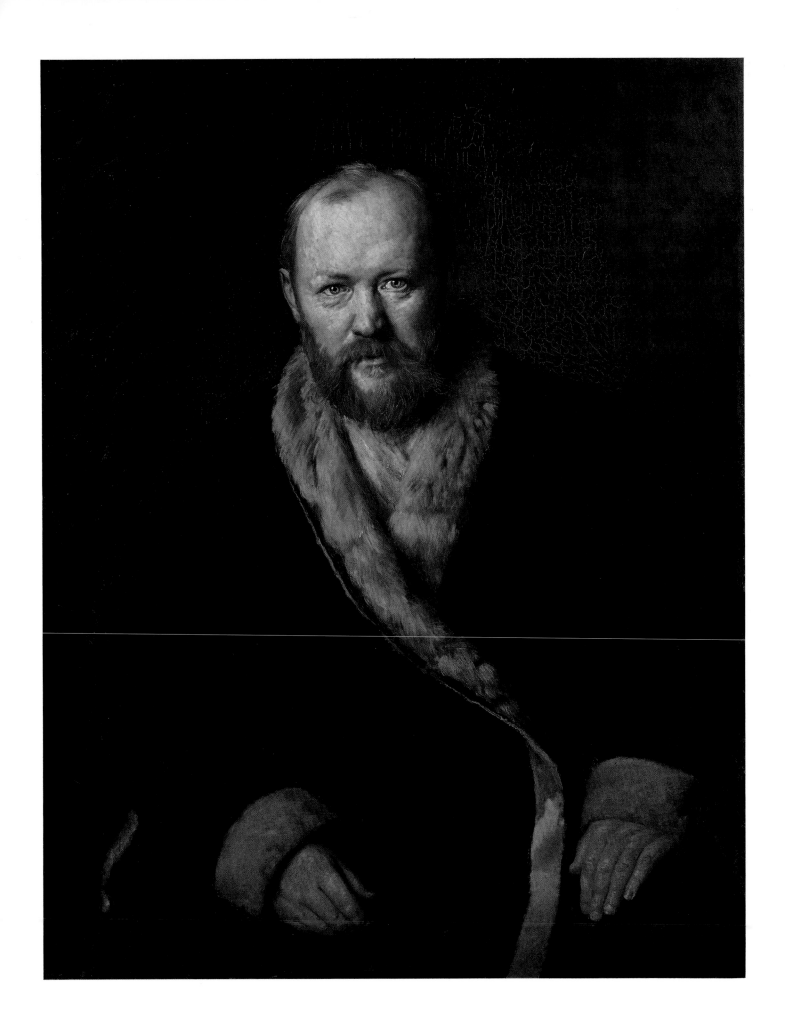

Vasilii Dmitrievich Polenov

Petersburg 1844-1927 Borok Estate (now Polenovo, Tula Oblast)

A Courtyard in Moscow

As a student at the Petersburg Academy of Arts from 1863 to 1871, Vasilii Dmitrievich Polenov took lessons in painting from P.P. Chistiakov and I.N. Kramskoi before he lived and worked in Paris (1872-1876) on a scholarship from the Academy. In 1876 he became a member of the Academy. Polenov lived in Moscow from 1877; later he moved to the Borok estate in the Tula Province. A member of the Circle of the Itinerants and a constant participant in their art exhibitions, Polenov was also associated with S.I. Mamontov's Abramtsevo Art Circle. He taught at the Moscow School of Painting, Sculpture, and Architecture (1882-1895) and organized the first Moscow Folk Theater in 1910. In addition to his many trips to countries in Western Europe, Polenov traveled to the Near East and Greece in his search for subjects and themes for his genre scenes and historical and biblical paintings. Of particular significance is Polenov's contribution to Russian landscape painting, which was enriched by his experimentations with plein air techniques.

"An unexpectedly festive occasion was the appearance . . . of Polenov's first intimate landscape at the very end of the 1870s. I was exceptionally moved by his Courtyard in Moscow, Grandmother's Orchard, and Overgrown Pond . . . and a number of other 'Turgenev-like' motifs; they appeared to me unexpectedly new and fresh, permeated with authenticity, subtle, musical lyricism, and a most delicate technique" (from the reminiscences of the artist I.S. Ostroukhov).

Oil on canvas on paperboard, 49.8 x 38.5 cm, 1877

Signed, lower right (with monogram): VP 1877

The State Tretyakov Gallery, Moscow

Inv. #11151

Accessioned from I.S. Ostroukhov's Museum of Icons and Art in 1929; earlier in the collection of I.S. Ostroukhov, Moscow

One of the most popular pictures of Russian art of the late nineteenth century was *A Courtyard in Moscow* by Polenov, a smaller sketch of which is featured in this exhibition. A picturesque corner of old Moscow is depicted in the work. The painter was spellbound by the virtually rural, patriarchal way of life, which was already disappearing even in his day.

76

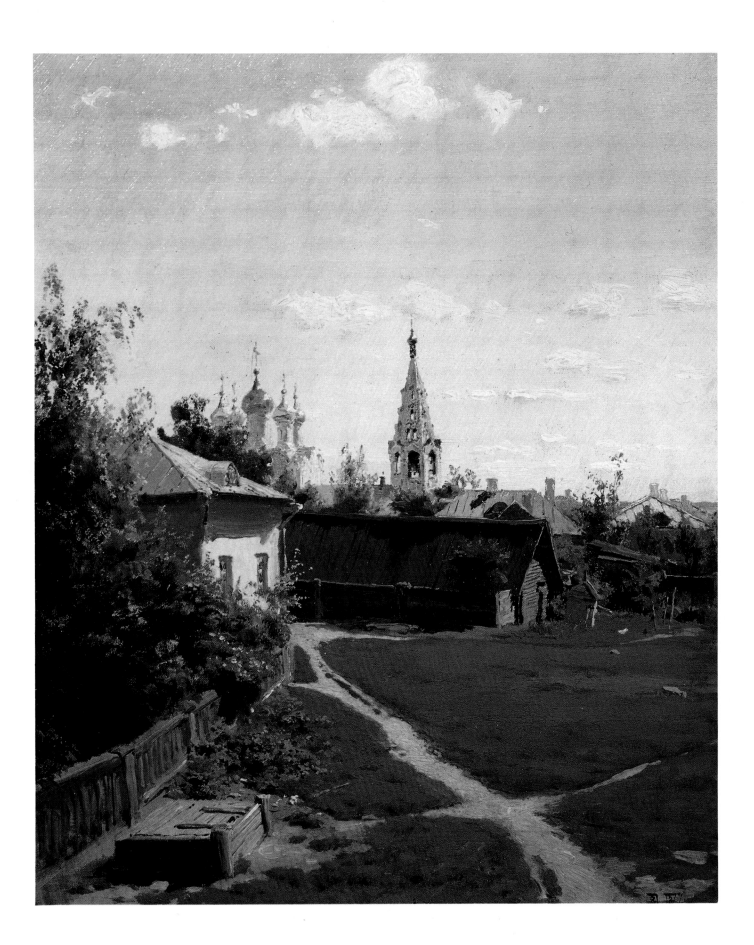

Vasilii Dmitrievich Polenov

Overgrown Pond

Oil on canvas, 44 x 64.5 cm, 1880

Signed, lower right: V. Polenov 80 (letters V and P intertwined)

The State Russian Museum, Leningrad

Inv. #4212

Accessioned from the Leningrad Purchase Commission in 1946; earlier in the collection of V.I. Dvorshchin

A smaller version of the 1879 painting is now in the collection of the State Tretyakov Gallery.

Two versions of the landscape *Overgrown Pond,* along with the well-known *Courtyard in Moscow,* were completed during the productive period of the artist's career. Vasilii Polenov realized upon his return from abroad that being a landscape painter was his calling; the lyrical nature and masterful realism of his landscapes attracted critical attention, and Polenov was soon compared to the artist Savrasov.

In the painting *Overgrown Pond,* the figure of a young woman standing in the shade — the artist's sister, V. D. Polenova, served as the model — lends the landscape a gentle mood while it simultaneously provides a narrative element: the presence of the girl in the ancient park evokes associations with images created by [realist writer] Ivan Turgenev.

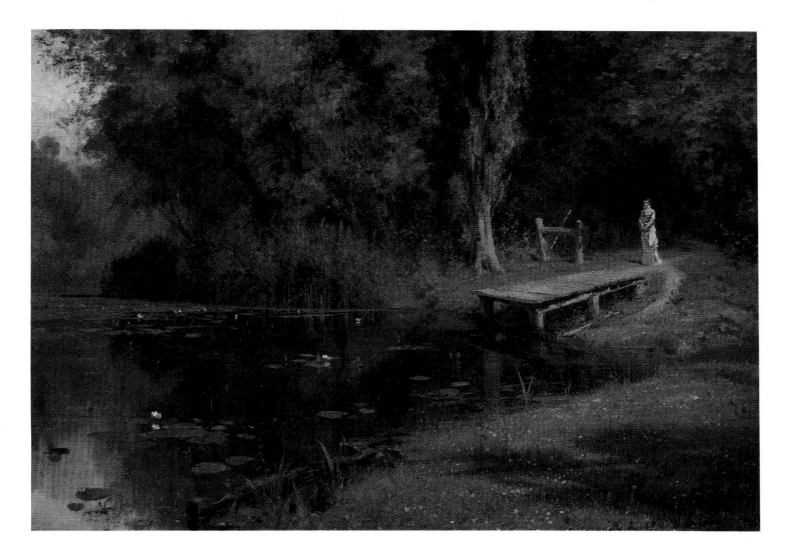

Vasilii Vladimirovich Pukirev

village of Luzhniki, Tula Province 1832-1890 Moscow

Checking the Dowry List

Vasilii Vladimirovich Pukirev studied at the Moscow School of Painting, Sculpture, and Architecture from 1847 to 1853 and later taught there as well (1861-1873). A resident of Moscow, Pukirev painted genre scenes and portraits that played a significant role in establishing Russian realism during the 1850s and 1860s.

Oil on canvas, 66 x 83 cm, 1873

Signed, lower right: V. Pukirev 1873

The State Tretyakov Gallery, Moscow

Inv. #352

Acquired by P. M. Tretyakov

The painting was executed following the traditions of Russian genre scenes of the late 1850s and 1860s: small in size, an everyday event with an obligatory social message, interesting subject matter, and an elaborately detailed presentation of a *mise en scène*. The scene depicts a merchant's son, with fault-finding pettiness, checking the list against the objects included in his young wife's dowry.

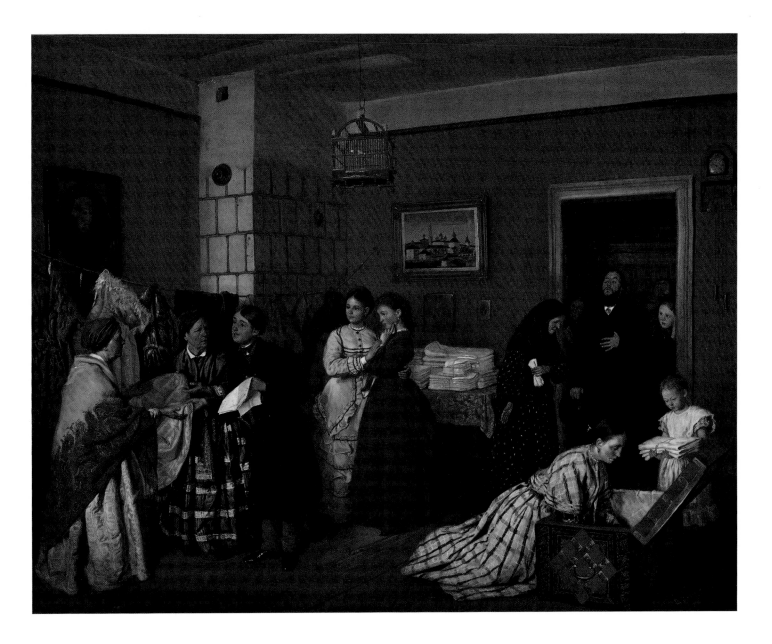

Ilya Efimovich Repin

Chuguevo, Kharkov Province 1844-1930 Kuokkala, Finland (now Repino, Leningrad Oblast)

The Cossacks

Ilya Efimovich Repin ranks as the most prominent figure of nineteenth-century Russian realism. Son of a simple military settler (a peasant), Repin was naturally endowed with an uncommonly strong artistic talent. He studied at the Petersburg Academy of Arts from 1864 to 1871. While a student, Repin became friends with I. N. Kramskoi, who exerted a particularly powerful influence both on the young artist and on his fellow artists in Petersburg. On a scholarship from the Academy, Repin lived and worked in Paris from 1873 to 1876, at which time he became a member of the Academy. In 1877 he returned to his birthplace in Chuguevo, moved to Moscow the next year, and then lived in Petersburg from 1882 on. From 1878 to 1882 Repin, along with V. M. Vasnetsov and V. D. Polenov, comprised the nucleus of S. I. Mamontov's Abramtsevo Art Circle. Beginning in 1878 as well, Repin was a member of the Itinerants and a constant participant in their exhibitions. He served as a professor and as head of the studio affiliated with the Petersburg Academy of Arts (1894-1907) and as director of the Academy in 1898-1899. At about this same time, Repin taught at the studio-school of the Princess M. K. Tenisheva.

A painter of landscapes, genre scenes, and portraits, Repin often depicted themes from history in his works, especially in his landscapes. He was also an accomplished master of drawing, and he produced several lithographs. In 1900 Repin took as his permanent residence the estate Penaty in Kuokkala, a village in the vicinity of Petersburg. This estate soon became an established center of Russian artistic and literary activity in the early twentieth century.

"On the basis of his huge, and perfectly extraordinary talent, he deserves a prominent place in more than just the history of Russian art" (A. N. Benois, 1902).

Oil on canvas, 67 x 87 cm, 1880

Signed, lower middle: 18. . Repin

The State Tretyakov Gallery, Moscow

Inv. #757

Acquired by P. M. Tretyakov in 1891 from D. I. Iavornitskii

This preliminary oil sketch served as a basis for the well-known painting *Zaporozhye Cossacks Writing a Mocking Letter to the Turkish Sultan* that was executed in 1891 and is now located in the State Russian Museum in Leningrad. The subject of this painting is derived from Russian-Ukranian history of the seventeenth century, when the freemen of the Zaporozhye Sech bravely defended the southern frontiers of the Russian state from frequent raids by Turkish-Crimean forces. Repin worked on this picture with tremendous enthusiasm. In an 1880 letter to V. V. Stasov he wrote, "I have been living with them about two-and-a-half weeks without a break (that is with the Cossacks), cannot part with them, a merry lot! . . . No wonder Gogol wrote about them, it is all true! Amazing people! . . . Nobody in the whole world has so deeply felt freedom, equality, and brotherhood!"

P. P. Chistiakov, a well-known Russian artist, noted of this work, "There are few artists even in Europe who respond to the color and drama so strikingly and so perfectly."

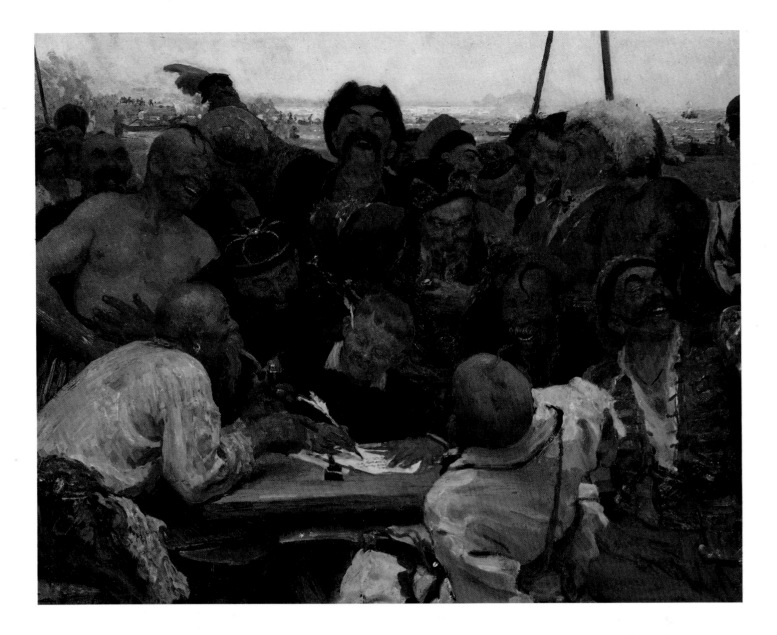

Ilya Efimovich Repin

Portrait of the Pianist,
Conductor, and Composer, A.G. Rubinstein

Oil on canvas, 80 x 62.3 cm, 1881

Signed, upper right: 1881 I. Repin

The State Tretyakov Gallery, Moscow

Inv. #729

Acquired by P.M. Tretyakov from the artist

The portrait depicts the prominent Russian musician and composer Anton Grigorievich Rubinstein (1829-1894), founder of the Petersburg Conservatory. P.M. Tretyakov specially commissioned this work by Repin for his portrait gallery of outstanding figures of Russian culture and art.

"In his portraits Repin achieved the apogee of his painting power. Some of the works are absolutely striking in the temperament with which they are depicted" (A.N. Benois, 1902).

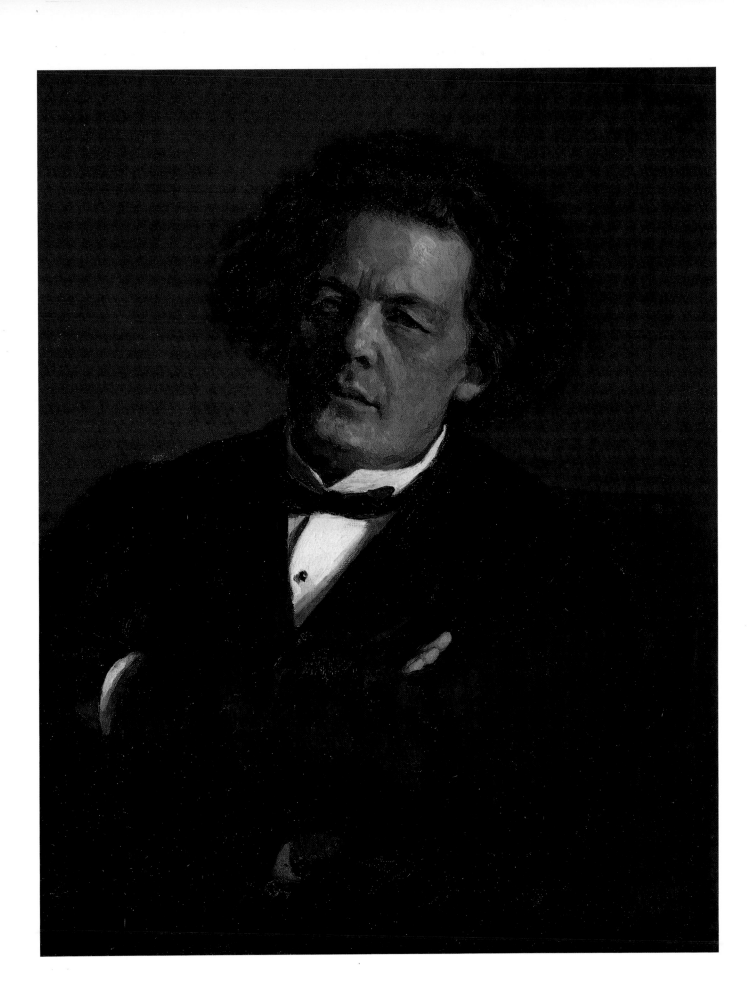

Ilya Efimovich Repin

Autumn Bouquet. Portrait of Vera Repina

Oil on canvas, 111 x 65 cm, 1892

Signed, lower right: 1892 I. R'pin

The State Tretyakov Gallery, Moscow

Inv. #758

Acquired from the artist; gift of P.M. Tretyakov in 1893

The work depicts Vera Ilyinichna Repina (1872-1948), the artist's elder daughter. By virtue of its artistic qualities, the portrait belongs to the very best works not only of Repin but also of all Russian art in the early 1890s.

"It conveys magnificently in its joyful unity with nature the feeling of a healthy and happy youth" (O. A. Laskovskaia).

Ilya Efimovich Repin

Portrait of Semenov-Tian-Shanskii

Oil on canvas, 97 x 62 cm, 1901

Signed, lower left: 1901. I R'pin

The State Russian Museum, Leningrad

Inv. #4034

Acquired in 1905 from the artist

This is a study for the 1903 painting, now in the State Russian Museum, called *The Formal Session of the State Council of May 7, 1901, on the Day of the Centenary of Its Establishment.*

In connection with the centenary of the State Council, Ilya Repin, as the leading portrait painter of his time, was offered a government commission: to compose a painting depicting this dignified session of the Council. In essence, the group portrait was to represent the most significant members of the Council during their state ceremony in the hall of the Marinsky Palace in Petersburg.

Because of its grandiose design (the final canvas measures 400 x 877 cm, and eighty persons are portrayed), Repin worked long and carefully on the scene, having access to all sessions of the Council with the right to paint and draw its members from life. The vast majority of the persons in the picture were painted ahead of time in one to three sittings and were positioned in the hall according to their respective places on the Council. The brevity of the actual session dictated the generalized nature of the painted studies, which convey only the basic features of each model. This preliminary portrait is typical of Repin's depictions of the outstanding people of his time.

In all his various state, social, and scholarly activities, Semenov should be remembered for his extensive explorations of the Tian-Shan mountain range which he undertook in 1856-1857, for his long tenure as the vice-president and leader of the Russian Geographic Society, and for his leading role in organizing a number of investigative expeditions. A major collector and a connoisseur of Dutch and Flemish painting as well, Semenov-Tian-Shanskii bequeathed his collection to the Hermitage, where it now resides.

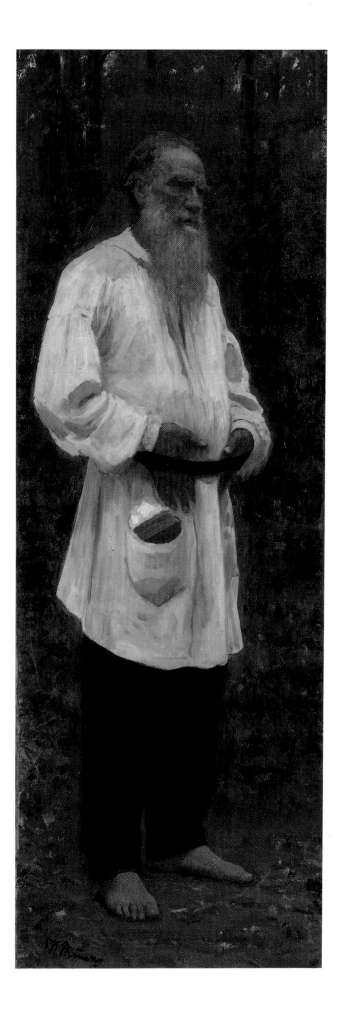

Ilya Efimovich Repin

Lev Nikolaevich Tolstoi (Barefoot)

Oil on canvas, 207 x 73 cm, 1901

Signed, lower left: I. Repin

The State Russian Museum, Leningrad

Inv. #4010

Acquired in 1901 from the artist

An 1891 sketch of the same work and title is in the State Tretyakov Gallery.

The friendship uniting Russian writer Leo Tolstoy and Repin went back many years. Repin visited the author on more than one occasion at his Yasnaya Polyana estate near Tula, and with Tolstoy's permission he produced several paintings and drawings, thus leaving an entire portrait gallery of images.

During his visits to Yasnaya Polyana in 1891, Repin executed a sketch which he subsequently used as a study for this portrait. He started one portrait in 1891, completing it two years later. The nature of this particular portrait as well as of the earlier study reflects to a certain extent the writer's spiritual searching: during this period of his life Tolstoy sought "simplicity" and often engaged in peasant labors.

Spellbound by his association with Tolstoy, Repin wrote to his daughter upon his return to Petersburg from Yasnaya Polyana, "No matter the self-abasements of this giant, or his choice of perishable rags to cover his mighty body, Zeus always shows in him, and all of Olympus trembles from the play of his eyebrows."

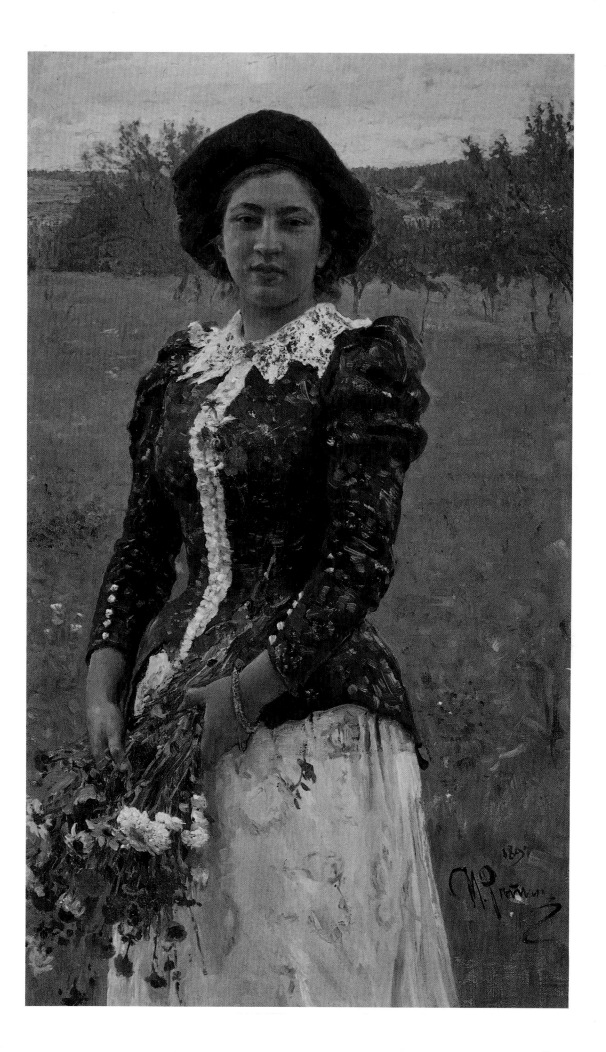

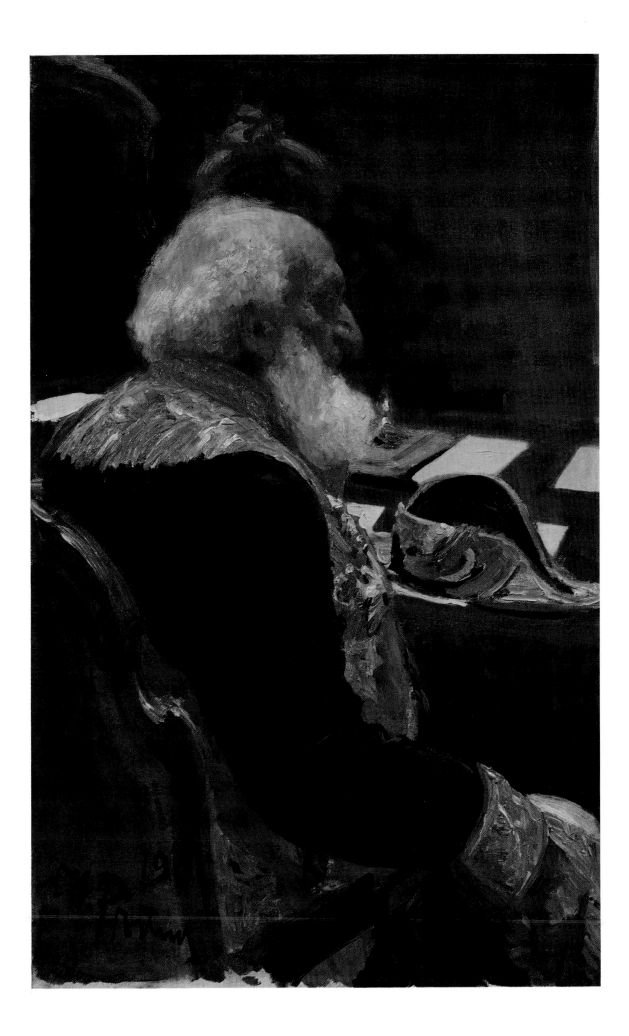

Arkadii Aleksandrovich Rylov

village of Istobenskoe (now Istobensk, Kirov Oblast) 1870-1939 Leningrad

Whispering Woods (The Green Noise)

A well-educated artist, Arkadii Aleksandrovich Rylov attended the Central School of Technical Drawing run by A. L. Stieglitz in Petersburg, where he studied with K. Ia. Kryzhitskii (1888-1891). He also took courses at the Drawing School of the Society for Encouraging Artists (he eventually taught there from 1902 to 1917) and at the Higher Art School affiliated with the Academy, where he was instructed by A. I. Kuindzhi. Rylov later taught at the Petrograd State Free Art Studios and at the Higher Arts and Industrial Design Institute in Leningrad (1918-1922), becoming a professor in 1921 and heading the landscape studio from 1918 to 1929. A frequent participant in the exhibitions organized by the 36 Artists, Rylov was periodically associated as well with World of Art between 1900 and 1913, the Union of Russian Artists (exhibiting his works with them from 1903 to 1910 and from 1911 to 1923), and from around 1905, the New Society of Artists. (In that same year he became an honorary member of the *Salon d'Automne* in Paris.) He was elected a member of the Academy in 1915. Before joining the Association of Artists of Revolutionary Russia in 1925, Rylov was a founding member of the A. I. Kuindzhi Society and took part in their exhibitions in 1917 and 1918. In 1935 he was recognized as an esteemed figure in the arts of the Russian Soviet Federal Socialist Republic.

In his numerous landscapes, Rylov attempted to create a generalized but nevertheless romantic depiction of the motherland. His landscapes and works dealing with historical, revolutionary subjects include compositions of epic themes.

Oil on canvas, 107 x 146 cm, 1904

Signed, lower right: A. Rylov 1904

The State Russian Museum, Leningrad

Inv. #1545

Accessioned from A. F. Gaush in 1919

Variations of the painting of the same name and year are in the State Tretyakov Gallery; a 1909 version is in the Kiev Museum of Russian Art.

First exhibited at the 1904 Spring Exhibition at the Academy of Arts, the work brought acclaim to the young artist. The painting, with its broad, free brushstrokes, reflects the intense, spiritual life of the progressive people of Russia on the eve of the 1905 Revolution and vividly demonstrates the artist's individuality. It embodies a heightened, joyful response to nature as well as sensitivity to its constant motion — a hymn to life and its forces, as it were.

In his *Reminiscences* Rylov wrote: "I worked a great deal on this motif, redoing and recomposing it several times while trying to capture the feeling of the mirthful sound of the birches and of the broad expanses of the river. In the summer I lived on a steep, tall bank of the Viatka River. The birch trees by the windows rustled for days at a time, growing quiet only toward the evening: a wide river coursed by, and vistas with woods and lakes were in the distance." Konstantin Bogaevskii, a friend and a fellow student of the artist in the Kuindzhi workshop, began reciting verses by Nekrasov upon seeing the canvas for the first time — "The green noise is building and humming . . ." — thus giving the painting an unusual but amazingly accurate title.

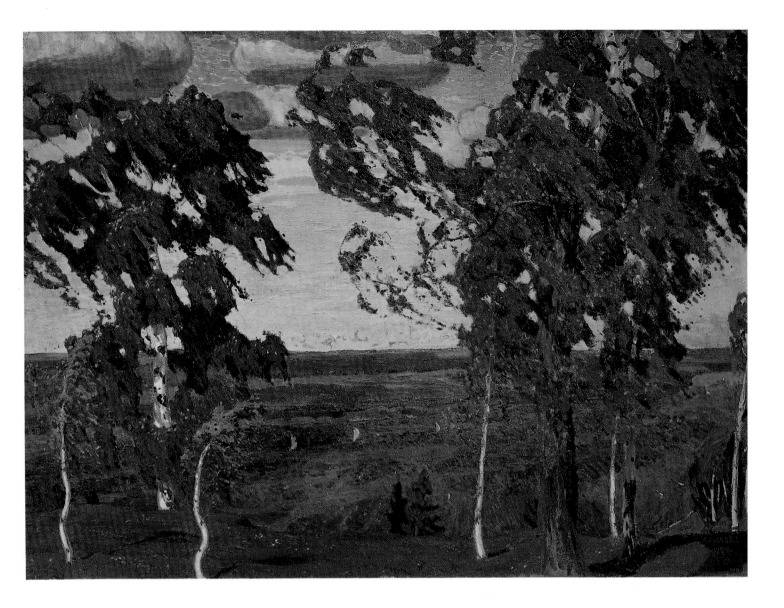

Aleksei Kondratievich Savrasov

Moscow 1830-1897 Moscow

The Steppe in the Afternoon

<u>A</u>fter ten years of study (beginning in 1844) with K. I. Rabus at the Moscow School of Painting, Sculpture, and Architecture, Aleksei Kondratievich Savrasov achieved the rank of member of the Academy in 1854. Although based in Moscow, Savrasov traveled frequently, taking trips to England, France, Germany, and Switzerland in 1862, to Paris in 1867, and to the Volga River and to the Ukraine several times between 1870 and 1875. He organized and headed (1857-1882) a landscape painting class at the Moscow School, where his followers included K. A. Korovin and I. I. Levitan. From 1861 Savrasov held membership in the Moscow Society of Art Lovers, and in 1870 he became a founding member of the Circle of the Itinerants. In addition to these groups, the artist participated in numerous exhibitions held at the Academy of Arts, in international exhibitions in Vienna (1873) and Paris (1878), and in 1882 the All Russian exhibition in Moscow, among others. Savrasov, an accomplished draftsman and landscape painter, is considered the originator of the lyrical landscape in late nineteenth-century Russian realist painting.

"Beginning with Savrasov, there was a lyricism in landscape painting as well as an endless love for one's own country . . ." (Levitan).

Oil on canvas, 73.5 x 104.5 cm, 1852

Signed, lower left: 1852 A. Savrasov

The State Russian Museum, Leningrad

Inv. #6660

Accessioned from A. S. Kuznetsov in 1957

This work, executed during one of the young artist's many trips to the Ukraine, clearly indicates his creative direction. Despite the established tradition in the mid-nineteenth century of applying hypothetical rules and techniques to romantic landscape paintings, Savrasov chose a completely prosaic subject matter, which might have seemed a drab location even with the considerable size of the canvas. The artist's direct and admiring attitude to all that is real in nature, however, enabled him to impart life into the scene and to animate the landscape that attracted him.

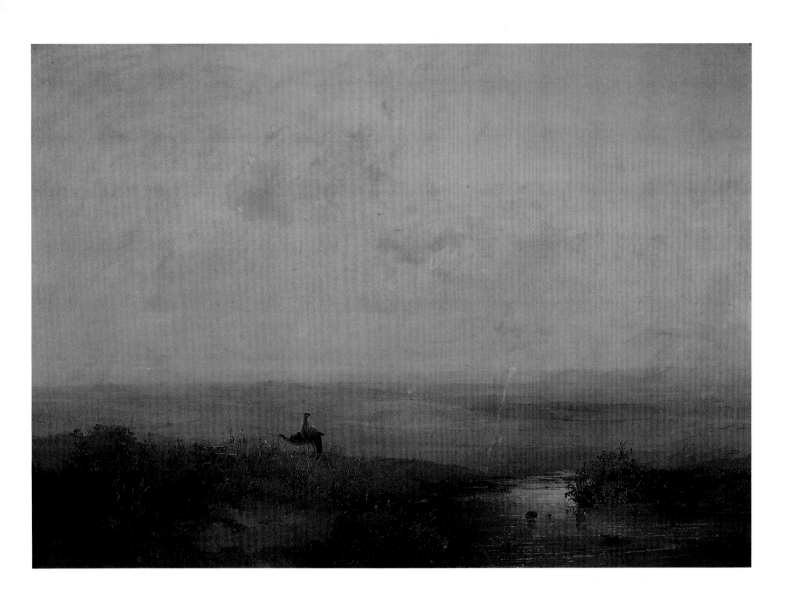

Aleksei Kondratievich Savrasov

Spring Thaw, Yaroslavl

Oil on canvas, 53.5 x 75.5 cm, 1874

Signed, lower middle (on raw canvas):
1874 A. Savrasov
Later signed, lower left: 1872 A. Savrasov

The State Russian Museum, Leningrad

Inv. #4116

Accessioned from the Committee on Art Affairs
with the Council of Ministers of the Russian
Federal Soviet Republic in 1946

One of the largest rivers in the European part of Russia, the Volga has long occupied an important place in Russian art, personifying the motherland in folk art and in the people's psyche.

Between 1870 and 1875 Savrasov took yearly trips to the Volga and worked for long stretches of time along the river. Similar to a number of other works in this cycle, the painting *Spring Thaw, Yaroslavl* is distinguished by a free and nontraditional selection of landscape motif, the expression of the artist's complex feelings when confronted with nature, the introduction of social elements that inform the landscape, and the inclusion of specific interpretative, emotional colors.

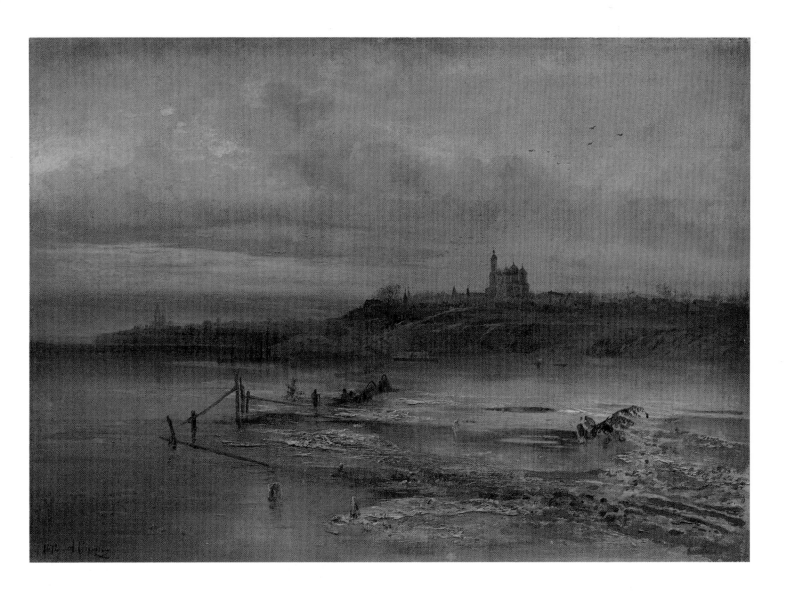

Valentin Aleksandrovich Serov

Petersburg 1865-1911 Moscow

Portrait of the Painter I. I. Levitan

Valentin Aleksandrovich Serov began his art training by studying with K. Koepping (1873-1874) and later with I. E. Repin (1874-1875 and 1878-1880). He then was a pupil of P. P. Chistiakov at the Petersburg Academy of Arts from 1880 to 1885. For long periods of time he lived at Abramtsevo, the country estate of the well-known art patron Savva Mamontov, where he was a part of the Abramtsevo Art Circle. He graduated from the Academy in 1884 and became an active member in 1903. Two years later, however, he left the Academy in protest over the Tsarist government's shooting at the workers' demonstration on January 9, 1905, which marked the beginning of the first Russian Revolution.

In addition to teaching at the Moscow School of Painting, Sculpture, and Architecture from 1897 to 1909, Serov participated in the Circle of the Itinerants and their art exhibitions (1894-1899) and in the societies of World of Art (1899-1903) and the Union of Russian Artists (1903-1909). The greatest portraitist of his time, Serov continued the traditions of late nineteenth-century realist portraiture, which were made richer by the achievements of Impressionism. In his later years, Serov's works presaged the artistic developments of twentieth-century painting. He produced landscape paintings as well as historical compositions and genre scenes.

Oil on canvas, 82 x 86 cm, 1893

Signed, lower right: Serov 93

The State Tretyakov Gallery, Moscow

Inv. #1520

Acquired from the artist in 1894; gift of P. M. Tretyakov that year

This portrait of the artist Isaak Ilych Levitan (1860-1900) is one of Serov's best known works.

Valentin Aleksandrovich Serov

Portrait of the Grand Duchess Olga Aleksandrovna as a Child

Oil on canvas, 60 x 49 cm, 1893

Signed, lower right: Serov 93

The State Russian Museum, Leningrad

Inv. #1918

Acquired from an exhibition of V. A. Serov's works in 1914; earlier in the collection of the Empress Mariia Fedorovna

In the spring of 1892, Serov received a commission on I. E. Repin's recommendation for a large painting depicting the Emperor Alexander III and his family. It was ordered for the hall of the Kharkov Gentry Association, which wanted to celebrate the survival of the Tsar's family in a train wreck at the Borki train station near Kharkov on October 17, 1888.

Serov's request to paint the family from life was not immediately granted. The monarch Alexander III had never before posed for an artist, and Serov received one opportunity to attend one of the emperor's appearances. The three younger members of the family — the Grand Duke Mikhail Aleksandrovich [Romanov] and the Grand Duchesses Olga (1882-1952) and Kseniia — did sit for Serov's study portraits, which he painted from life in three sessions per portrait. Serov's studies of Mikhail and Olga are now in the State Russian Museum, while that of Kseniia remains in the Pskov Art History Museum and Sanctuary.

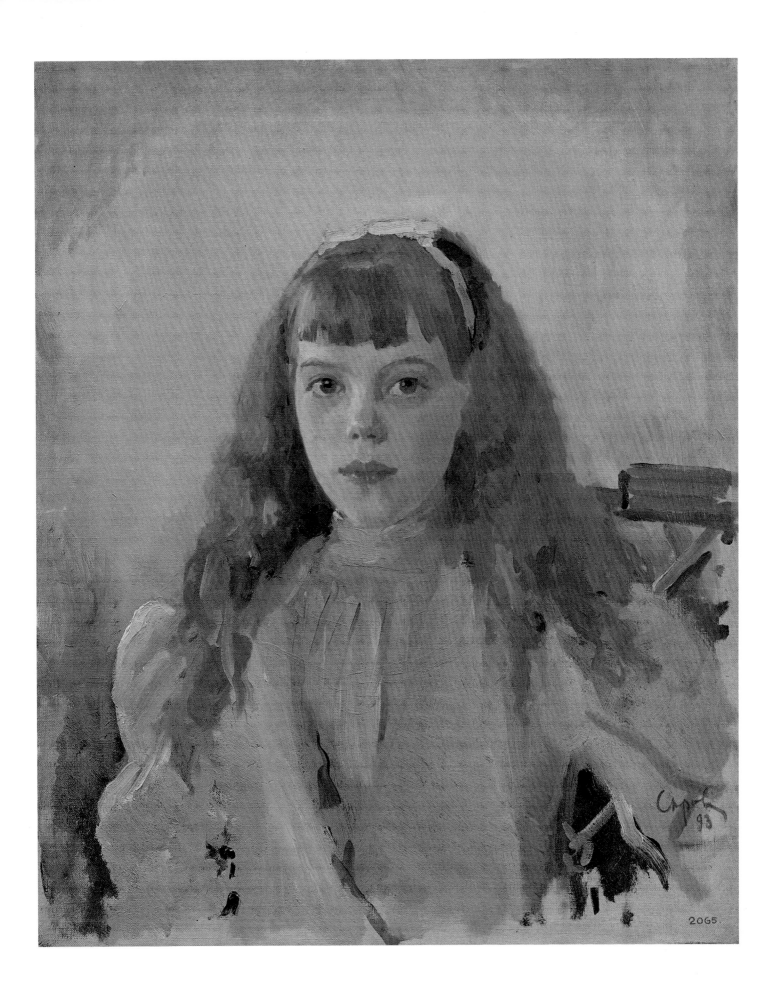

Valentin Aleksandrovich Serov

Portrait of M. K. Oliv

Oil on canvas, 88 x 68.5 cm, 1895

The State Russian Museum, Leningrad

Inv. #4284

Accessioned from Iu. A. Mamontov in 1904

The first husband of Mara Konstantinovna Oliv (1870-1963) was Iurii Anatolevich Mamontov, the nephew of Savva Ivanovich Mamontov, into whose home Serov was received as a member of the family. I. E. Grabar spoke enthusiastically about this work: "He [Serov] chose a most challenging situation of having a model sit for him deep in the interior of a room as light plays upon the face and accessories in a restrained manner, and the effect is something like chiaroscuro. . . . Unfortunately not everyone appreciated his phenomenal achievement; in the history of painting it was the similar — if not entirely the same — problem that Rembrandt alone posed for himself and solved. In the most contemporary French paintings, so highly sophisticated in the realm of the 'unprecedented,' they are unknown."

A mildly ironic remark from the artist about his model has also survived: "She resembles a young mouse peeking out of a dark corner with two sharp eyes."

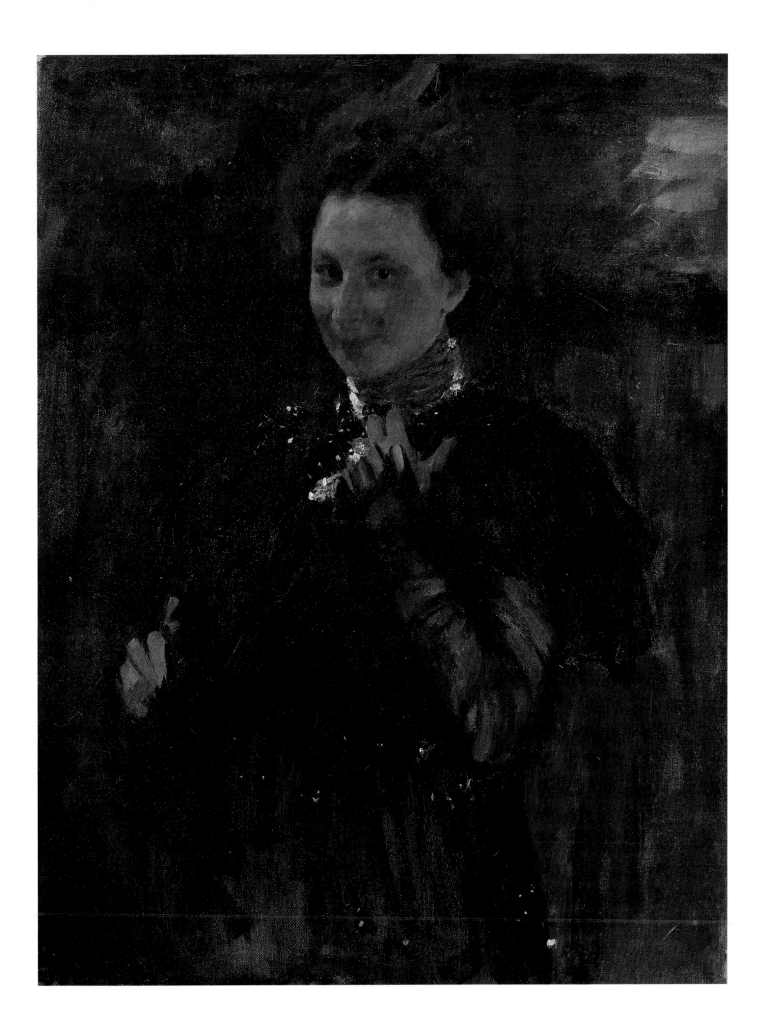

Valentin Aleksandrovich Serov

Portrait of S. P. Diaghilev

Oil on canvas, 97 x 83 cm, 1904

The State Russian Museum, Leningrad

Inv. #1922

Accessioned from the All Soviet Federation on Export "Antiquariat" in 1930; earlier in the collection of Iu.P. Diaghilev

Sergei Pavlovich Diaghilev (1872-1929) was one of the founders of World of Art, serving as editor of the journal, organizer of its exhibitions, and originator of the modernist movement in Russian art, all linked to this name. He also avidly promoted Russian art abroad, producing concerts of Russian music and "seasons of Russian ballet" in France and other foreign countries.

Serov got the idea to paint a portrait of S.P. Diaghilev in the summer of 1904, when he was present at the beginning of L.S. Bakst's work on his well-known *Portrait of S. P. Diaghilev with His Nanny* (also in the State Russian Museum). That fall Serov started to paint Diaghilev in the latter's Petersburg apartment, which then also housed the editorial staff of World of Art, but the artist soon cooled to the work, and the portrait remained unfinished.

Diaghilev's appearance at that time and the direct impression the portrait captured were mentioned in the memoirs of a contemporary: ". . . The man himself is young and handsome with a full rosy face, bright black eyes, and an ever mocking, gentle smile on his sensuous lips. His dark hair is cut as if it were a thick brush, and from the right side above the forehead, a paradoxical tuft of white hair stands out sharply. The outward appearance of Diaghilev is captured superbly in the unfinished portrait, really almost a sketch by Serov. This sketch conveys his characteristic hand gesture, raised and pointing out at the level of his head."

Ivan Ivanovich Shishkin

Pine Trees in Sunlight

Oil on canvas, 102 x 70.2 cm, 1886

Signed, lower middle: I. Sh. 1886 Sestroretsk

The State Tretyakov Gallery, Moscow

Inv. #840

Acquired by P.M. Tretyakov in 1886 from the artist

One of Shishkin's best studies of nature, this painting is technically finished and clearly constructed in composition. The study was done in the picturesque environs of Sestroretsk, a tiny village near Petersburg and the artist's favorite place for his outdoor work.

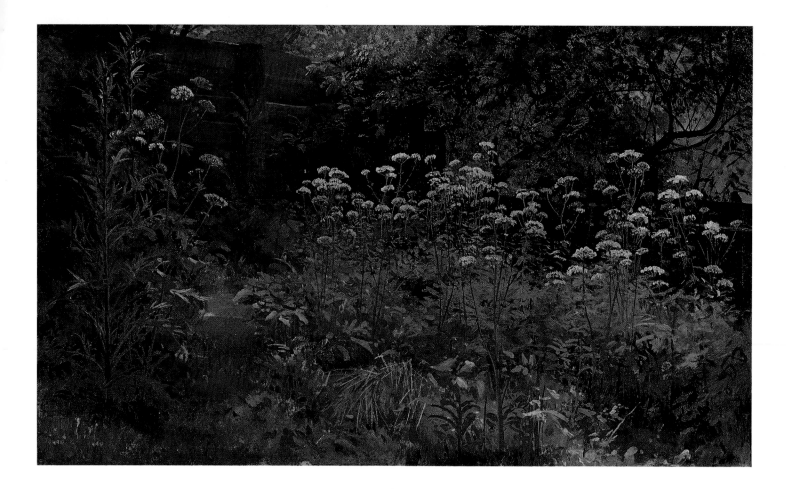

Ivan Ivanovich Shishkin

Elabuga, Viatka Province (now Tatar Autonomous Soviet Socialist Republic) 1832-1898 Petersburg

Goutweed, Pargolovo

After he studied at the Moscow School of Painting, Sculpture, and Architecture (1852-1855), Ivan Ivanovich Shishkin attended the Petersburg Academy of Arts from 1856 to 1860, completing his studies with the highest honors and a gold medal. Five years later, in 1865, he attained the rank of member of the Academy, and then in 1873 that of professor. He also headed in 1894-1895 and in 1897 the landscape painting class at the Higher Art School affiliated with the Academy of Arts.

Before he received these professional honors, Shishkin lived and worked abroad in Switzerland and Germany (1862-1865), spending half a year in the Zurich workshop of R. Koller and residing in Düsseldorf for one year. Upon his return to Petersburg, Shishkin became one of the founding members of the Circle of the Itinerants, and he joined the Society of Russian Watercolorists. Among the exhibitions in which his works were included were those at the Academy of Arts, the All Russian Exhibition in Moscow in 1882, the Nizhnii Novgorod in 1896, and the World Fairs held in Paris (1867 and 1878) and Vienna (1873).

A highly esteemed master of Russian realist landscape painting, Shishkin's creative method was based on exhaustive, analytical studies and on a kind of "portraiture" of nature that exposed its most typical features. Distinguished for his forest landscapes, Shishkin is known not only as a painter but also as an outstanding draftsman and printmaker.

Oil on canvas on paperboard, 35 x 58.5 cm, 1884(5?)

Stamped, on verso: I.I. Shishkin's Study

The State Russian Museum, Leningrad

Inv. #4132

Accessioned from the Academy of Arts in 1931

This study was completed in Siverskaia in the vicinity of Petersburg, where Shishkin often spent the summer with fellow artist I.N. Kramskoi. Kramskoi admired his friend's careful skills of observation and the confidence with which he worked. "When he faces nature . . . he is truly in his own element: he is daring and deft, he does not hesitate. . . ." This landscape shows Shishkin's profound understanding of the life of nature, his ability to see beauty in what seems at first glance mundane, and his talent at reproducing diverse forms of vegetation with almost uncanny precision.

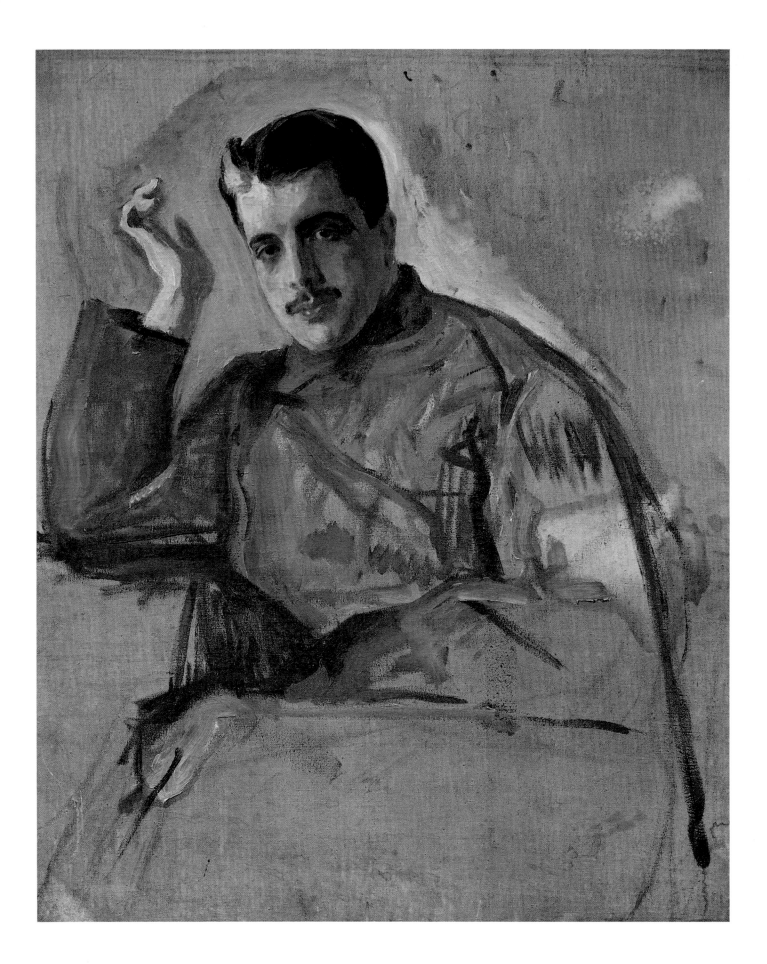

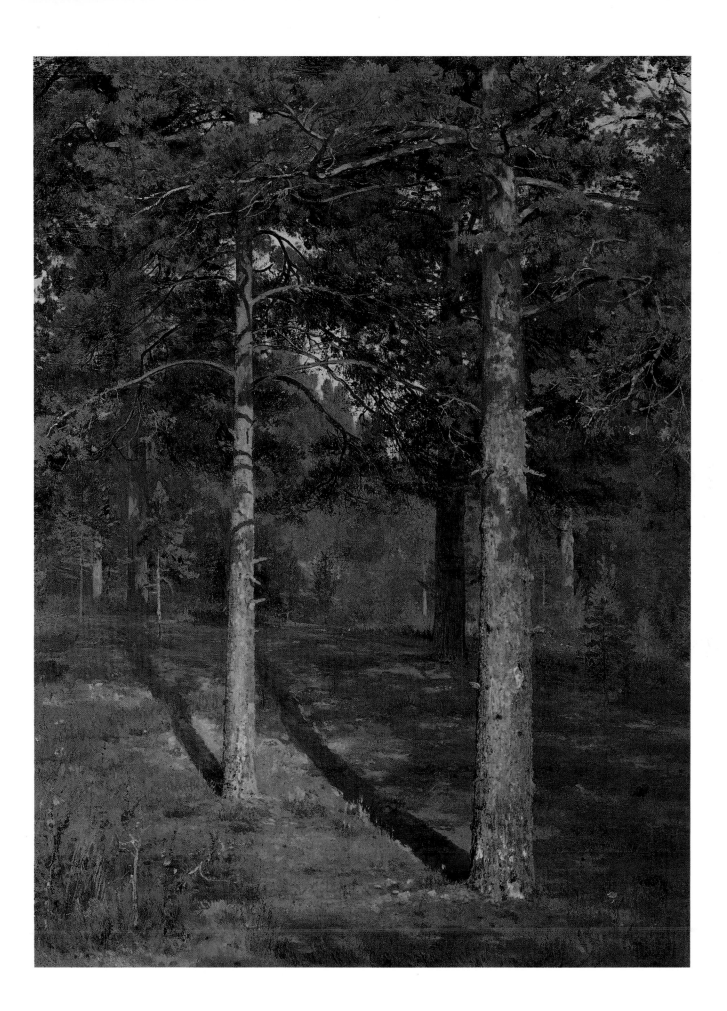

Ivan Ivanovich Shishkin

Mordvinov's Oak Trees

Oil on canvas, 84 x 111 cm, 1891

Signed and inscribed, lower right: I. Sh. 1891. at the summer home of the Count Mordvinov

The State Russian Museum, Leningrad

Inv. #4131

Accessioned from E.A. Ermolova in 1918

Executed freely and confidently, this landscape was created during the height of the artist's talent, when he devoted much attention to the problem of capturing the sense of light and air. Here, sunlight forms an important component of the image as it enhances the scene's expressive vitality. At the same time, Shishkin's drawing is disciplined, his contours appear finished, and he is particularly sensitive to the rendering of form. As with other works throughout his career, the leading theme of nature's power, richness, and beauty finds a vivid manifestation in this painting.

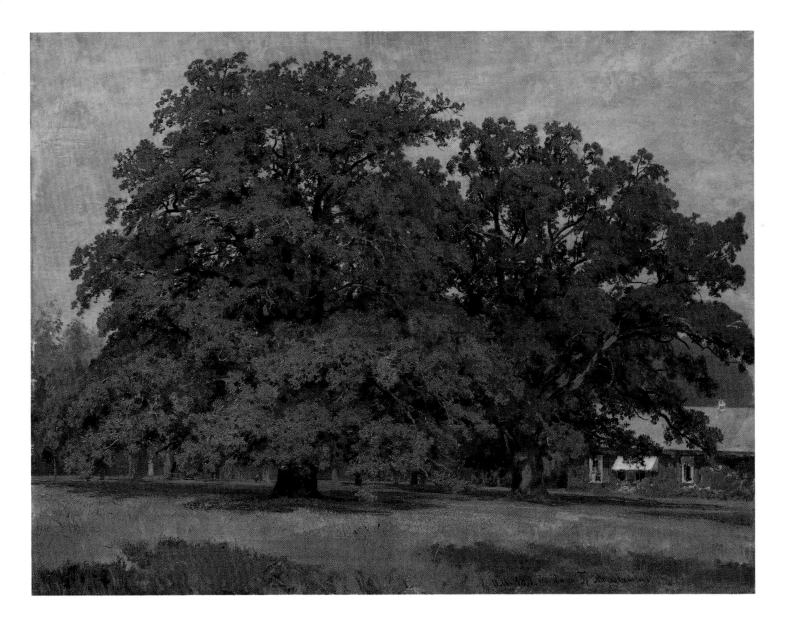

III

Vasilii Ivanovich Surikov

Krasnoyarsk 1848-1916 Moscow

The Monument to Peter I on Senate Square in Petersburg

As an outstanding representative of nineteenth-century Russian realism, Vasilii Ivanovich Surikov is recognized for his brilliant and unique talent, and his powerful, creative temperament. He studied with P. P. Chistiakov at the Petersburg Academy of Arts from 1869 to 1875, receiving the title of member in 1895. Although he lived primarily in Moscow after 1877, Surikov traveled to Italy, Germany, and France in 1883-1884 and journeyed to Spain in 1910. Born into a long line of Siberian cossacks, he also took trips to Siberia regularly as well as to the river Don (1893), the Volga (1901-1903), and to the Crimea. He was a member of the Circle of the Itinerants and a frequent participant in their exhibitions after 1881. Surikov is best known for his large-scale historical compositions, although he also painted portraits and was fascinated with watercolors.

"... Surikov is the most Russian of the Russian artists and the only historical painter among them to whom the label 'great' adheres" (A. Efros in *Profiles,* 1930).

Oil on canvas, 52 x 71 cm, 1870

Signed, lower right: V. Surikov 1870

The State Russian Museum, Leningrad

Inv. #4241

Accessioned from the State Museum Fund in Leningrad in 1928

The painter depicted here one of the most beautiful historic sites in Petersburg — Senate Square on the bank of the Neva, with its monument to the great reformer of the Russian state, Peter I, and its majestic St. Isaac's Cathedral. This painting, Surikov's first independent work completed shortly after his enrollment in the Academy of Arts, ranks as the earliest manifestation of his interest in the epoch of Peter I and in the theme of Russia's heroic past. In a romantically heightened interpretation of the city's appearance, the artist's emotional response to nature is apparent. Furthermore, the work reveals his talent for painterly generalizations.

Surikov painted this scene in the summer of 1870, using studies he had made in the winter, and he exhibited the painting at the Academy the next autumn. The landscape, however, did not satisfy him. Several months later he created another version of the picture, but this time he painted the snow-covered square from life in an effort to convey a greater degree of subtlety in the dual source of light and the reflections on the snow. This second version belongs to the State Russian Museum; the first version is in the Regional Art Gallery in Surikov's birthplace of Krasnoyarsk.

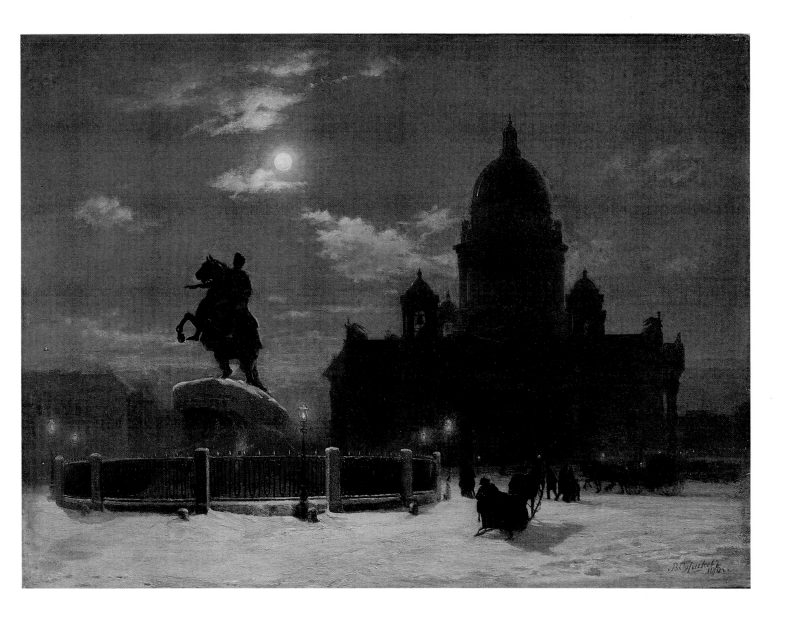

113

Vasilii Ivanovich Surikov

The Boyarina Morozova

Oil on canvas, 48.7 x 72 cm, 1881

Signed, lower left: V. Surikov 81

The State Tretyakov Gallery, Moscow

Inv. #6085

Accessioned from the State Tsvetkov Gallery in 1926; earlier in the collection of I. E. Tsvetkov, Moscow

The first sketch of this large painting, dated 1877, is located in the State Tretyakov Gallery in Moscow. The painting's subject derives from Russian history of the second half of the seventeenth century. It describes the tragic fate of one of the active participants in the Church Schism Movement, the noblewoman, or *boyarina,* Morozova, the spiritual daughter of the fiery archpriest Avvakum. Refusing to submit to the new church rites introduced by the patriarch Nikon, the *boyarina* Morozova condemned herself to arrest and death in the monastery's dungeons. Surikov portrayed the scene when the *boyarina* departs from the common people as she is taken, disgraced, in a low, wide sled through Moscow for interrogation and imprisonment.

In the original sketch, Surikov convincingly conveys the drama of the situation, although the composition of the final canvas of 1887 offers a much more dynamic interpretation.

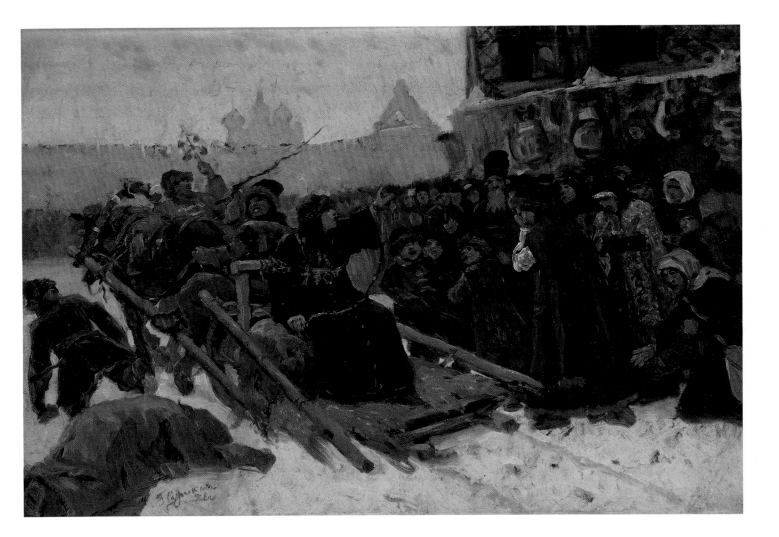

Vasilii Ivanovich Surikov

A Young Noblewoman in Her Blue Coat

Oil on canvas, 84.4 x 55.5 cm, 1887

Signed, lower left: V. Surikov 1887

The State Tretyakov Gallery, Moscow

Inv. #5832

Accessioned from the People's Commissariate of Foreign Affairs in 1925; earlier in the collection of P.I. and V.A. Kharitonenko, Moscow

This is a study for the painting *The Boyarina Morozova*.

"Surikov is more than just a great realist-scholar. In essence he is a poet who, perhaps without being aware of it himself, possesses a tremendous mystical talent. Just as Menzel is close in spirit to the mystic and realist Hoffman, in exactly the same way Surikov is close in spirit to the mystic and realist Dostoevsky. This similarity is best of all noticed in his feminine types who, in a somewhat strange way, combine within them a religious ecstasy with a deep and almost voluptuous sensuality" (A.N. Benois, 1902).

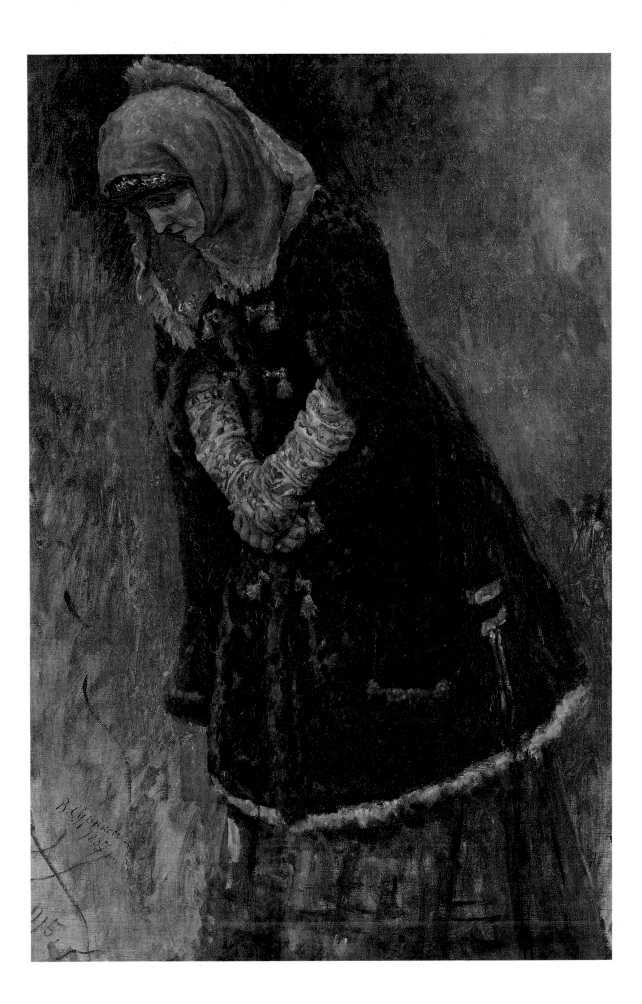

Vasilii Ivanovich Surikov

Yermak Conquers Siberia

Oil on canvas, 59 x 103 cm, 1895

The State Tretyakov Gallery, Moscow

Inv. #786

Gift of the artist in 1895

Based on Russian history of the sixteenth century, this painting illustrates how a group of fighting cossacks, led by their chieftain, Yermak Timofeevich, conquered the Siberian kingdom of Kyzyma Khan. The artist lends the aura of a legendary, epic event to this concrete, historic episode and its characters.

The smaller sized copy of this painting, also from 1895, is located in the State Russian Museum in Leningrad.

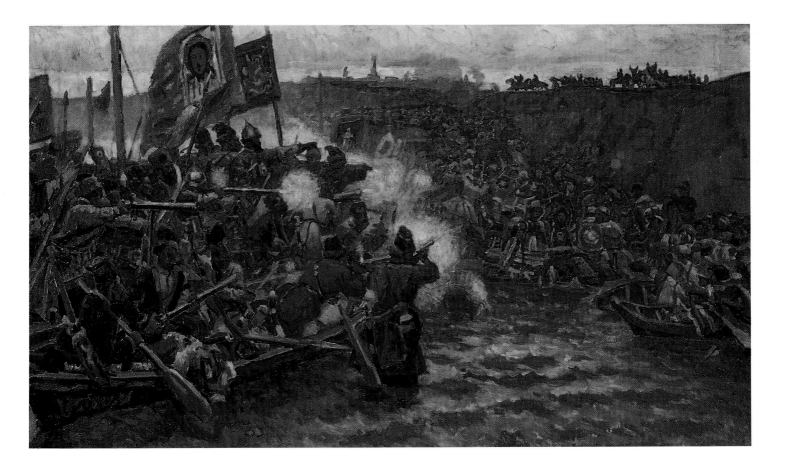

Fedor Aleksandrovich Vasiliev

near Petersburg 1850-1873 Yalta, Crimea

Before the Rain

Before he came under the tutelage of the well-known Russian landscape painter I. I. Shishkin, Fedor Aleksandrovich Vasiliev studied for four years, from 1863 to 1867, at the Drawing School of the Society for Encouraging Artists, located in Petersburg. After that he worked independently, painting and drawing landscapes. Vasiliev lived in Petersburg until mid-1871, when he moved to Yalta for reasons of health. He was a notable practitioner of Russian realist painting.

His friend and teacher, the artist I. N. Kramskoi, wrote, "I believe that he was destined to bring into the Russian landscape that which the latter lacked: . . . the poetic sense of nature."

Oil on canvas, 39.7 x 57.5 cm, 1870

Signed, lower right: F. Vasiliev

The State Tretyakov Gallery, Moscow

Inv. #901

Acquired by P. M. Tretyakov

An accomplished small-scale painting, F. A. Vasiliev completed it in his atelier from his impressions of nature. Particularly interesting is the high skill with which the tension-filled light before the rainstorm and the bright, lush colors are conveyed.

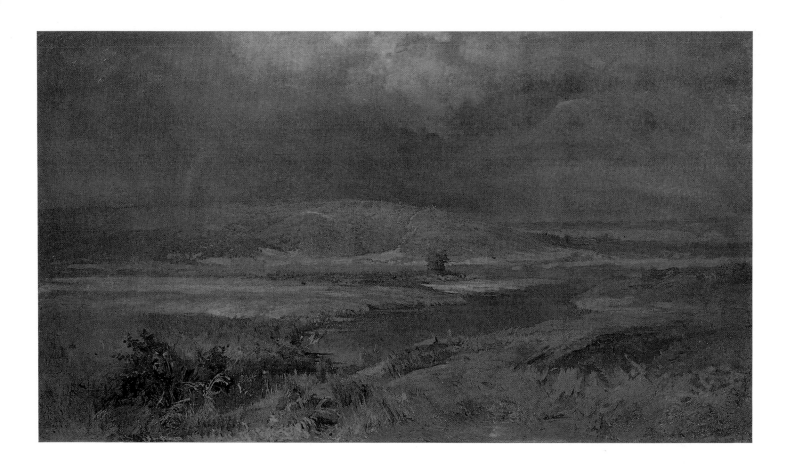

Fedor Aleksandrovich Vasiliev

The Volga Lagoons

Oil on canvas, 70 x 127 cm, 1870

The State Tretyakov Gallery, Moscow

Inv. #902

Acquired by P.M. Tretyakov in 1874 at a posthumous exhibition of the artist's work

One of the few large-scale works by this extremely gifted artist who died too soon, Vasiliev created this painting during his trip to the Volga in 1870. Besides its clever solution to the problem of spatial composition, this work is distinguished by its bright colors and decorative features, motifs typical of the mid-Volga region.

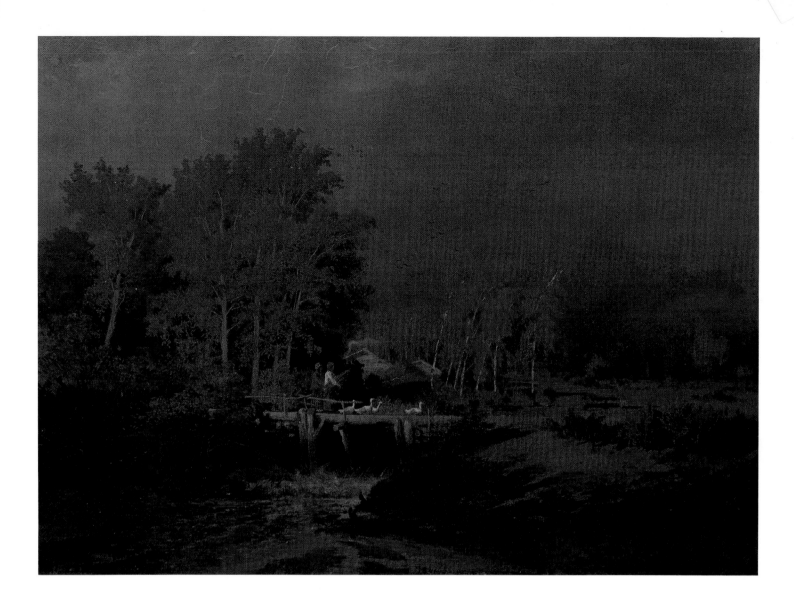

Apollinarii Mikhailovich Vasnetsov

village of Riabovo, Viatka Province (now Kirov Oblast) 1856-1933 Moscow

Motherland

Although Apollinarii Mikhailovich Vasnetsov did not receive a formal art education, his first teacher was his older brother, the artist V. M. Vasnetsov. Upon his arrival in Petersburg in 1872, A. M. Vasnetsov dedicated himself to self-education, attending "Repin's Thursdays" and drawing from nature a great deal. (He moved to Moscow six years later.) In his artistic training, A. M. Vasnetsov was indebted to S. I. Mamontov's Abramtsevo Art Circle, and the Itinerants V. D. Polenov and I. I. Shishkin also decisively influenced the young artist's work. A. M. Vasnetsov became a member of the Circle of the Itinerants in 1888 and was as well an active participant in the exhibitions of the Union of Russian Artists from 1903 on. During the 1880s he traveled widely in Russia, France, Italy, and Germany. He also taught at the Moscow School of Painting, Sculpture, and Architecture from 1901 to 1918. As an active member of the Moscow Archaeological Society, A. M. Vasnetsov chaired a commission to study old Moscow. He created numerous paintings on historical themes in addition to his work as a landscape painter, graphic artist, book illustrator, and theatrical artist.

Oil on canvas, 49 x 73 cm, 1886

Signed, lower left: Ap. Vasnetsov 1886

The State Tretyakov Gallery, Moscow

Inv. #967

Acquired by P. M. Tretyakov in 1886 from the artist

Distinguished by a poetic and vivid generalization of the features of nature in middle Russia, this is one of A. M. Vasnetsov's best early landscapes.

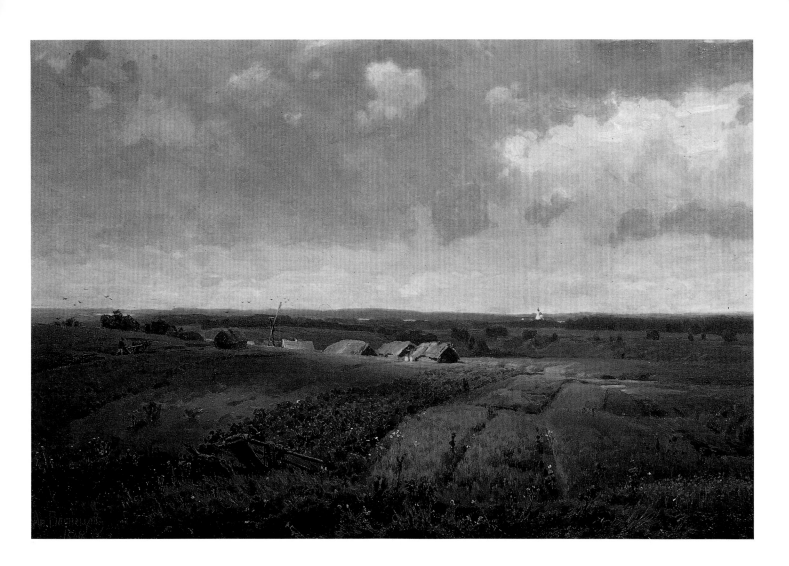

Viktor Mikhailovich Vasnetsov

village of Lopial, Viatka Province (now Kirov Oblast) 1848-1926 Moscow

Dressed as a Buffoon

Viktor Mikhailovich Vasnetsov studied with I. N. Kramskoi at the Drawing School of the Society for Encouraging Artists, located in Petersburg, in 1867-1868, before he took courses at the Petersburg Academy of Arts (1868-1874). He remained in Petersburg until 1878, and except for a six-year stay in Kiev (1885-1891), he resided in Moscow for the rest of his life.

A leading Russian artist of the late nineteenth century, V. M. Vasnetsov actively participated in the Itinerants' exhibitions after 1874. Early in his career, he made drawings and painted genre scenes. After he settled in Moscow, however, he dedicated his work almost exclusively to images of history and folklore. In the 1880s he became an organizer of and a participant in the Abramtsevo Art Circle led by S. I. Mamontov. He designed the theatrical backdrops for Mamontov's private staging of the opera *Snowmaiden* by N. A. Rimski-Korsakov in 1885, which initiated a reform movement in Russian theatrical decorative arts. From 1885 to 1896, V. M. Vasnetsov executed a huge mural in St. Vladimir's Cathedral in Kiev, which marked an important step in the renaissance of decorative arts in Russia. He also completed a number of architectural projects during the 1890s and 1900s, including the facade of the Tretyakov Gallery.

V. M. Vasnetsov represented the national-romantic trend in late nineteenth-century Russian realism. "Dozens of outstanding Russian artists drew from this national source — the talent of Viktor Vasnetsov" (artist M. V. Nesterov, 1916).

Oil on canvas, 66.5 x 52.2 cm, 1882

Signed, lower left: V. Vasnetsov 1882

The State Tretyakov Gallery, Moscow

Inv. #1011

Acquired by P.M. Tretyakov

The scene portrays a participant in one of S. I. Mamontov's private theatrical spectacles. In the late 1870s and especially during the 1880s, both in his home on Sadovaia Street and on his country estate "Abramtsevo," a large number of artists, actors, and other figures in the art world gathered around S. I. Mamontov, a well-known Russian industrialist and a patron of the arts. Beyond staging private theatrical productions, people worked, brainstormed, and argued about the paths of development appropriate to Russian art. In this way, the famous Abramtsevo Art Circle evolved and exercised an important influence on its contemporary Russian art. Within the Abramtsevo Circle, Russian artists cultivated their interest in folk art — costumes, embroidery, wood carving, pottery — and attempted to resurrect national forms and practices.

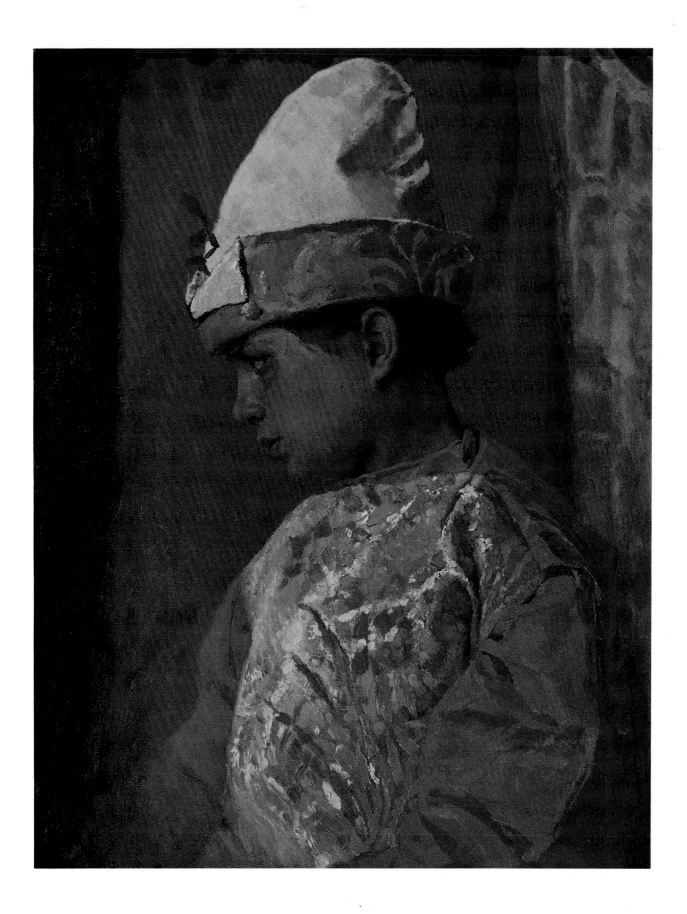

Viktor Mikhailovich Vasnetsov

Stone Age. Revelry

Oil on canvas, 56 x 80 cm, 1883

Signed, lower right: V. Vasnetsov

The State Tretyakov Gallery, Moscow

Inv. #11045

Accessioned from the I.S. Ostroukhov Museum of Icons and Art in 1929; earlier in the private collection of I.S. Ostroukhov; acquired from the artist

This work is a sketch of a section of the large mural *Stone Age* executed by V.M. Vasnetsov in 1883 to ornament a hall of the State Historical Museum in Moscow. Several sketches on the theme of revelry during the Stone Age attest to Vasnetsov's persistent search for the most convincing and expressive solution, both compositionally and in terms of color, to this theme that captured his attention.

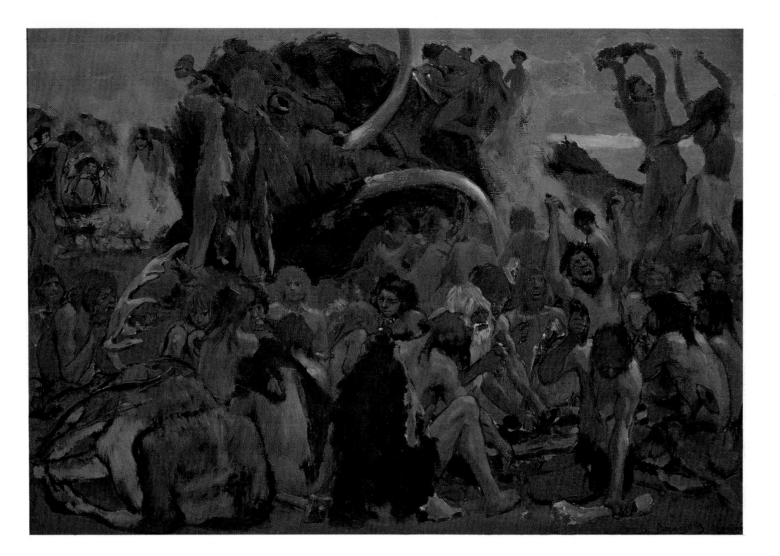

Vasilii Vasilievich Vereshchagin

Cherepovets, Vologda Oblast 1842-1904 Port Arthur, Japan

Dervishes Wearing Their Festive Clothes. Tashkent

Before he studied in the atelier of J.-L. Gérôme in Paris (1864-1865), Vasilii Vasilievich Vereshchagin attended the Petersburg Academy of Arts from 1861 to 1863. A tireless voyager, Vereshchagin journeyed widely throughout the various regions of Russia, visited nearly every country in Europe, and traveled to India on two occasions (1874-1876, 1882) as well as to Siberia, Palestine (1884), the United States, and Japan in the 1890s. As a military artist, Vereshchagin took part in the Turkestan War (1867-1870), the Russian-Turkish War (1877-1878), and the Russo-Japanese War (1904). He was killed in the latter war during the explosion of the Russian flagship "Petropavlovsk." His travels and ethnographic observations, in addition to his historical sketches and his participation in military campaigns, were not merely his artistic passion but also his means of support.

One of the best known Russian artists of battle scenes, Vereshchagin did not join the Circle of the Itinerants, even though he shared their viewpoints on art. Instead, he showed his own works in one-man exhibitions, grouping his paintings in series, as a rule. Vereshchagin lived most of his life in Petersburg and Moscow, although he had at different times studios in Paris and Munich (1871-1873).

In 1876, soon after the initial exhibition of a large series of works by Vereshchagin, artist I. N. Kramskoi responded to the numerous arguments and discussions the paintings elicited: "Vereshchagin is not the kind of artist whose works mainly stir one's heart; rather, I would say, he is a man who has taken an art form as a conduit for political, social, and religious ideas and has employed all the devices capable of affecting the minds of his contemporaries and has used them in his work brilliantly. . . ."

Oil on canvas, 71.6 x 47.2 cm, 1869-70

The State Tretyakov Gallery, Moscow

Inv. #1915

Acquired by P.M. Tretyakov in 1874 from the artist

This sketch from nature was executed by the artist during his second trip to Turkestan in 1869-1870.

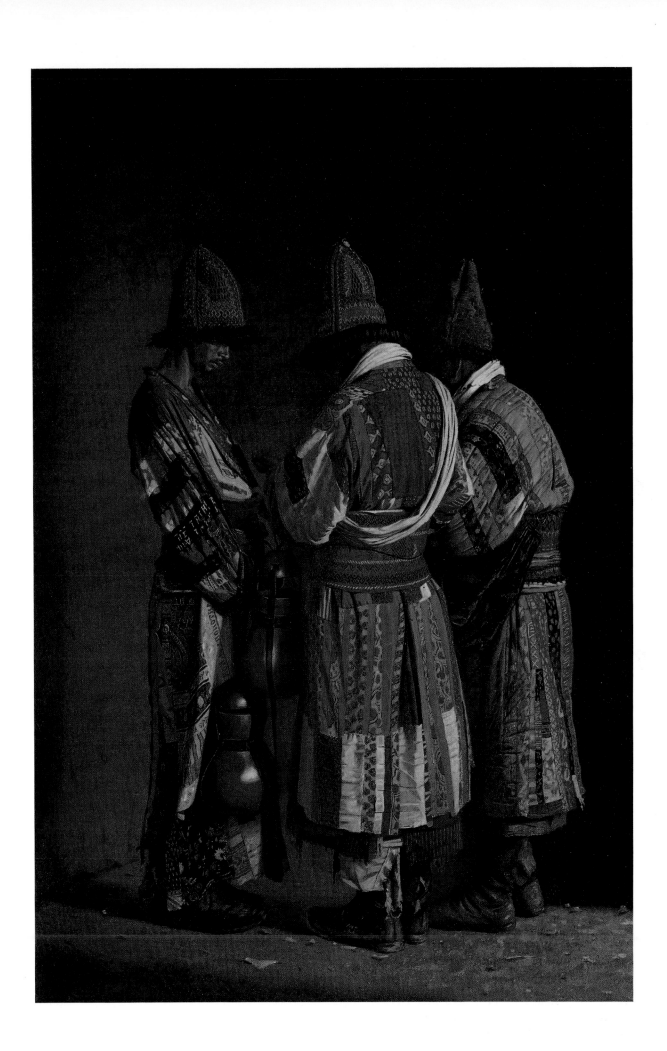

Vasilii Vasilievich Vereshchagin

Mortally Wounded

Oil on canvas, 73 x 56.6 cm, 1873

Frame includes artist's texts: (above) Aw brothers
they have killed me!. . They have killed me!. . . .
Aw my death has come!. . . .
(below) Mortally wounded

The State Tretyakov Gallery, Moscow

Inv. #2001

Acquired by P. M. Tretyakov in 1874 from the artist

The picture was painted in Munich in 1873
from sketches the artist made during his travels
to Turkestan.

Defining Vereshchagin's role in the history of
Russian art, the well-known early twentieth-
century art critic, A. N. Benois, wrote:
". . . Vereshchagin has repeated in his painting
what Tolstoy did in literature. . . . When . . .
the Russian public saw the painting of
Vereshchagin, suddenly so simply and so cyn-
ically exposing the war and showing its dirty,
repulsive, grim and colossal evil . . . the public
yelled out in all its voices and started with all
its might hating and loving such a daring
man. . . ."

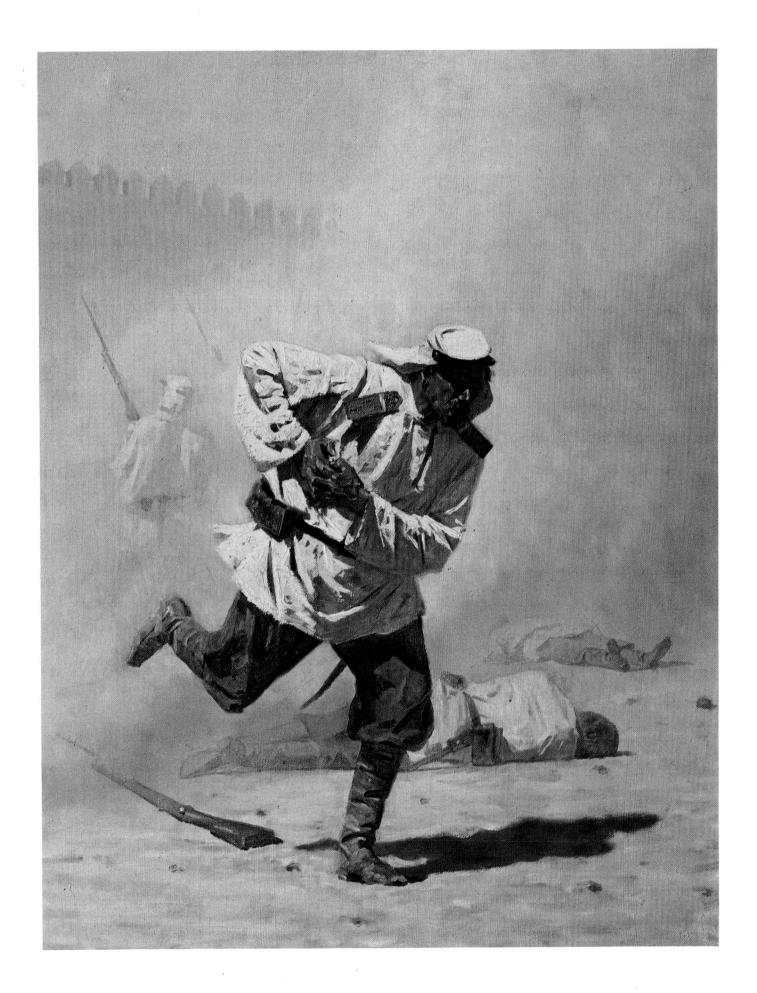

Vasilii Vasilievich Vereshchagin

134

Moti Masdzhid ("The Pearl Mosque")
in Agra

Oil on canvas, 31.7 x 45 cm, 1874-76

The State Tretyakov Gallery, Moscow

Inv. #2073

Acquired by P.M. Tretyakov in 1880

Vereshchagin produced this sketch from nature
during his first trip to India (1874-1876).

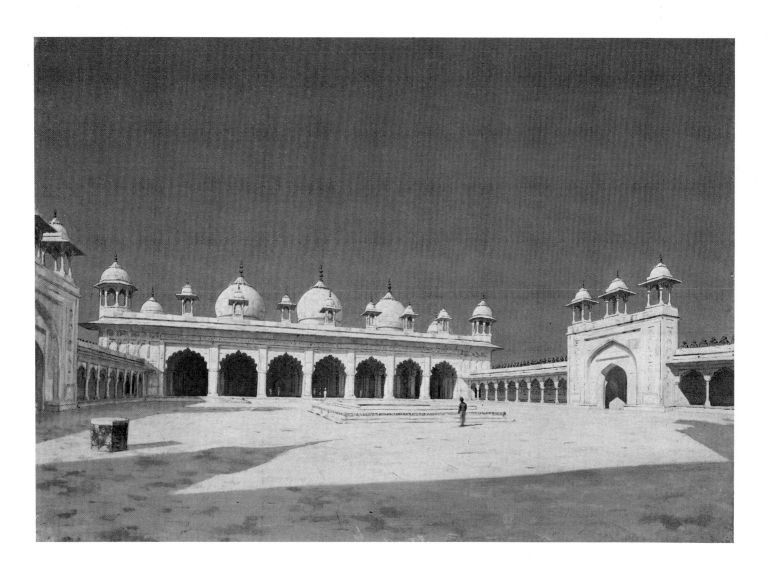

Sergei Arsenievich Vinogradov

village of Bolshie soli (now Kostroma Oblast) 1869-1938 Riga

Workers Eating Lunch

From 1880 to 1888, Sergei Arsenievich Vinogradov studied at the Moscow School of Painting, Sculpture, and Architecture with V. E. Makovskii, V. D. Polenov, and I. M. Prianishnikov. He lived primarily in Moscow until he moved to Riga in 1924. A painter of genre scenes, landscapes, and portraits, Vinogradov became a member of both the Circle of the Itinerants and the Union of Russian Artists in 1899.

Oil on canvas, 44.5 x 67 cm, 1890

Signed, lower right: S. Vinogradov 1890

The State Tretyakov Gallery, Moscow

Inv. #6122

Acquired by the Council of the Gallery in 1907

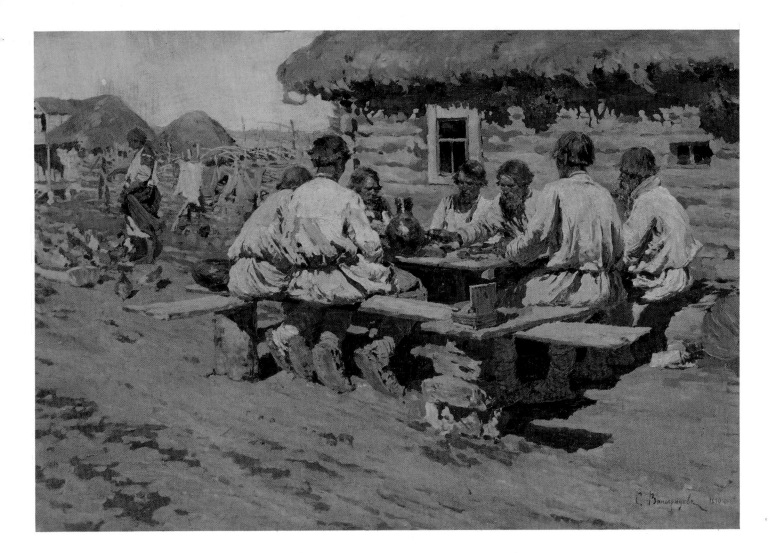

Stanislav Iulianovich Zhukovskii

village of Edrikhovichi (now Grodnensk Oblast) 1873-1944 Prushkovo, near Warsaw

A Room in the Brasovo Estate

Stanislav Iulianovich Zhukovskii studied with A. E. Arkhipov, I. I. Levitan, and V. A. Serov while he attended the Moscow School of Painting, Sculpture, and Architecture from 1892 to 1901. In 1904 Zhukovskii began to participate in the Circle of the Itinerants' art exhibitions and in those held by the Union of Russian Artists. After he moved from Moscow to Poland in 1923, the landscape artist taught at his own private school in Warsaw.

Oil on canvas, 80 x 107 cm, 1916

Signed, lower left: "Brasovo" S. Zhukovskii 1916

The State Tretyakov Gallery, Moscow

Inv. #28285

Accessioned from the People's Commissariate of Foreign Affairs in 1941

During the 1910s Zhukovskii received wide acclaim for his popular, stylish paintings of the interiors of country estates owned by the gentry. Although the images never depicted people, they were "populated" by a world of fine things and art objects that conveyed a subtle, elegant mood.

138

139

Selected Bibliography

Alpatov, Mikhail V. *Russian Impact on Art.* Edited by Martin L. Wolf. New York: Philosophical Library, 1950.

The Art of Russia 1800-1850. Loan exhibition catalogue. Introductory essay by John E. Bowlt. Minneapolis: University Gallery, University of Minnesota, 1978.

Azarkovich, V. G., comp. *Igor Grabar.* Leningrad: Aurora Art Publishers, 1977.

Benois, Aleksander N. *Istoriia zhivopisi v XIX veke: Russkaia zhivopis.* St. Petersburg, 1901-02.

_____. *The Russian School of Painting.* Introduction by Christian Brinton. Translated by Abraham Yarmolinsky. New York: Knopf, 1916.

Billington, James H. *The Icon and the Axe: An Interpretive History of Russian Culture.* New York: Knopf, 1966.

Bowlt, John E. "Two Russian Maecenases: Savva Mamontov and Princess Tenisheva." *Apollo* 48, no. 142 (December 1973): 444-453.

Chamot, Mary. *Russian Painting and Sculpture.* Oxford and London: Pergamon Press, 1963.

FitzLyon, Kyril, and Tatiana Browning. *Before the Revolution: Russia and Its People Under the Czar.* Woodstock, N.Y.: Overlook Press, 1978.

Gallwitz, Klaus, N. Novouspensky, and L. I. Iovleva. *Russischer Realismus: 1850-1900.* Baden-Baden: Staatliche Kunsthalle, 1972.

Grabar, I. E., V. N. Lazareva, and V. S. Kemenova, eds. *Istoriia russkovo iskusstva.* 12 vols. Moscow: Science Academy of the USSR, 1953-69. Based in part on Grabar's incomplete *Istoriia russkovo iskusstva.* 6 vols. 1908-15.

Gray, Camilla. *The Russian Experiment in Art: 1863-1922.* London: Thames and Hudson; New York: Harry N. Abrams, 1970. Originally published as *The Great Experiment: Russian Art, 1863-1922.* New York: Harry N. Abrams, 1962.

Grey, Ian. *The Horizon History of Russia.* Edited by Wendy Buehr. New York: American Heritage Publishing Co., 1970.

Hamilton, George Heard. *The Art and Architecture of Russia.* 2d ed. Baltimore: Penguin Books, 1977.

Hilton, Alison. "The Revolutionary Theme in Russian Realism." In *Art and Architecture in the Service of Politics.* Edited by Henry Millon and Linda Nochlin. Cambridge: MIT Press, 1978.

Korotkevich, E. Yu., and E. A. Uspenskaia. *Russian and Soviet Painting.* Loan exhibition catalogue. Introduction by Dmitrii Vladimirovich Sarabianov. Translated by John E. Bowlt. New York: The Metropolitan Museum of Art, 1977; distributed by Rizzoli International Publications, Inc.

Lebedev, Andrei, comp. *The Itinerants: Society for Circulating Art Exhibitions (1870-1932).* 2d ed. Leningrad: Aurora Art Publishers, 1982.

Loukomski, George K. (Georgii Kreskentevich Lukomskii). *History of Modern Russian Painting (Russian Painting of the Past Hundred Years, 1840-1940).* London: Hutchinson & Co., 1945.

Novouspensky, Nikolai, comp. *The Russian Museum, Leningrad: Painting.* Leningrad: Aurora Art Publishers, 1978.

Parker, Fan, and Stephen Jan Parker. *Russia on Canvas: Ilya Repin.* University Park and London: The Pennsylvania State University Press, 1980.

Razdobreeva, Irina Vasilievna. *"Russian Painters" Series: Levitan.* Leningrad: Aurora Art Publishers, 1971.

Rice, Tamara Talbot. *A Concise History of Russian Art.* New York: Frederick A. Praeger, 1963.

Sarabianov, Dmitrii Vladimirovich. *Russian Painters of the Early Twentieth Century (New Trends). (Russkie zhivopistsy nachala XX veka; novye napravleniia).* In English and Russian. Leningrad: Aurora Art Publishers, 1973.

Sarabianov, Dmitrii Vladimirovich, and Grigory Arbuzov. *Valentin Serov: Paintings, Graphic Works, Stage Designs.* Leningrad: Aurora Art Publishers; New York: Harry N. Abrams, 1982.

Savinov, Alexei, Alexei Fiodorov-Davydov, and Irina Shuvalova. *Shishkin.* Leningrad: Aurora Art Publishers, 1981.

Stavrou, Theofanis George, ed. *Art and Culture in Nineteenth-Century Russia.* Bloomington: Indiana University Press, 1983.

Sternin, Grigory, et al. *Ilya Repin: Painting, Graphic Arts.* Translated by Sheila Marnie and Helen Cleir. Leningrad: Aurora Art Publishers, 1985.

Stuart, John. "Social Revolution and the Arts." In *Art Treasures in Russia: Monuments, Masterpieces, Commissions and Collections.* New York and Toronto: McGraw-Hill Book Company, 1970.

Valkenier, Elizabeth. *Russian Realist Art, The State and Society: The Peredvizhniki and Their Tradition.* Ann Arbor: Ardis, 1977.

Volodarsky, Vsevolod, comp. *Painting: The Tretyakov Gallery, Moscow.* Translated by Nelly Fiodorova. Leningrad: Aurora Art Publishers, 1981.

Index of the Artists

RUSSIA: THE LAND, THE PEOPLE

Published by the Smithsonian Institution Traveling Exhibition Service
Andrea Price Stevens, Publications Director

Translated from the Russian by Nicholas Berkoff,
with assistance from Karen E. Anderson and Sally Hoffmann

Edited by Nancy Eickel, SITES

Designed by Gerard A. Valerio, Bookmark Studio, Annapolis, Maryland

Composed in Bembo Autologic by General Typographers, Washington, D.C.

Printed and bound by Balding + Mansell Ltd., Wisbech, Cambs., England

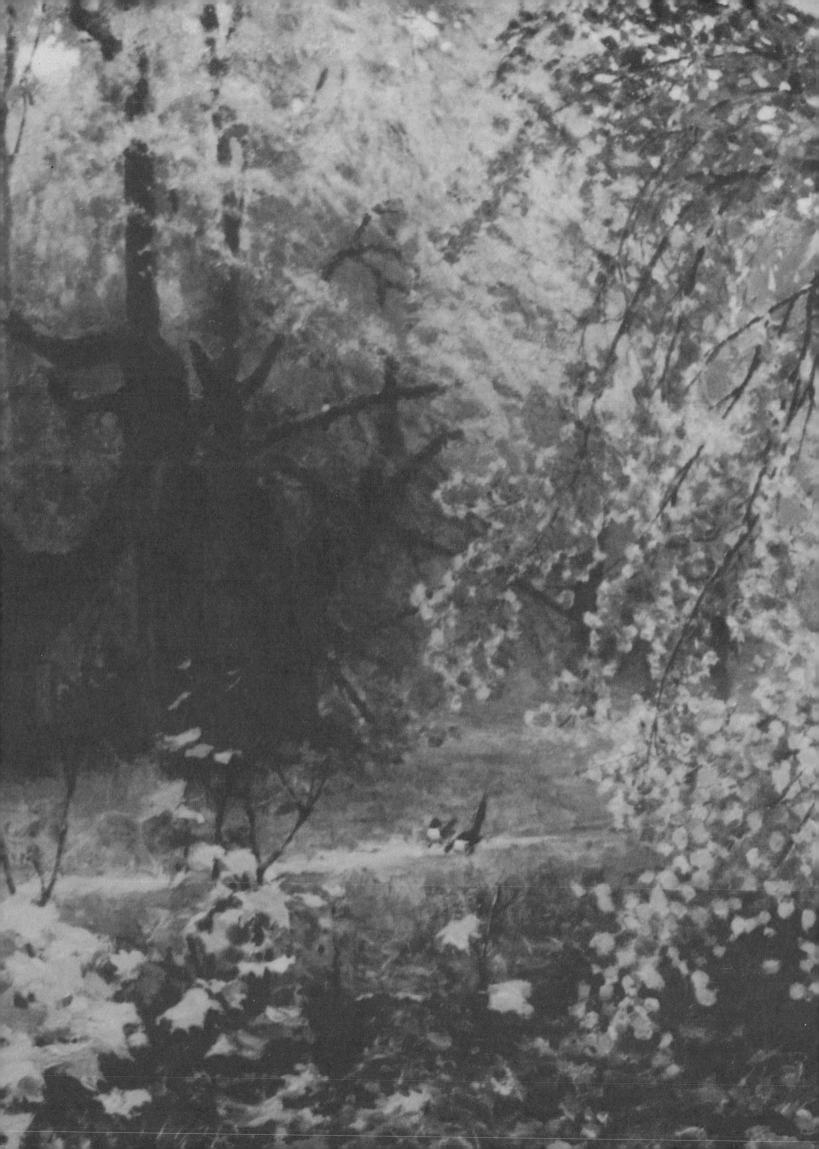